Images of America
Otsego and Plainwell

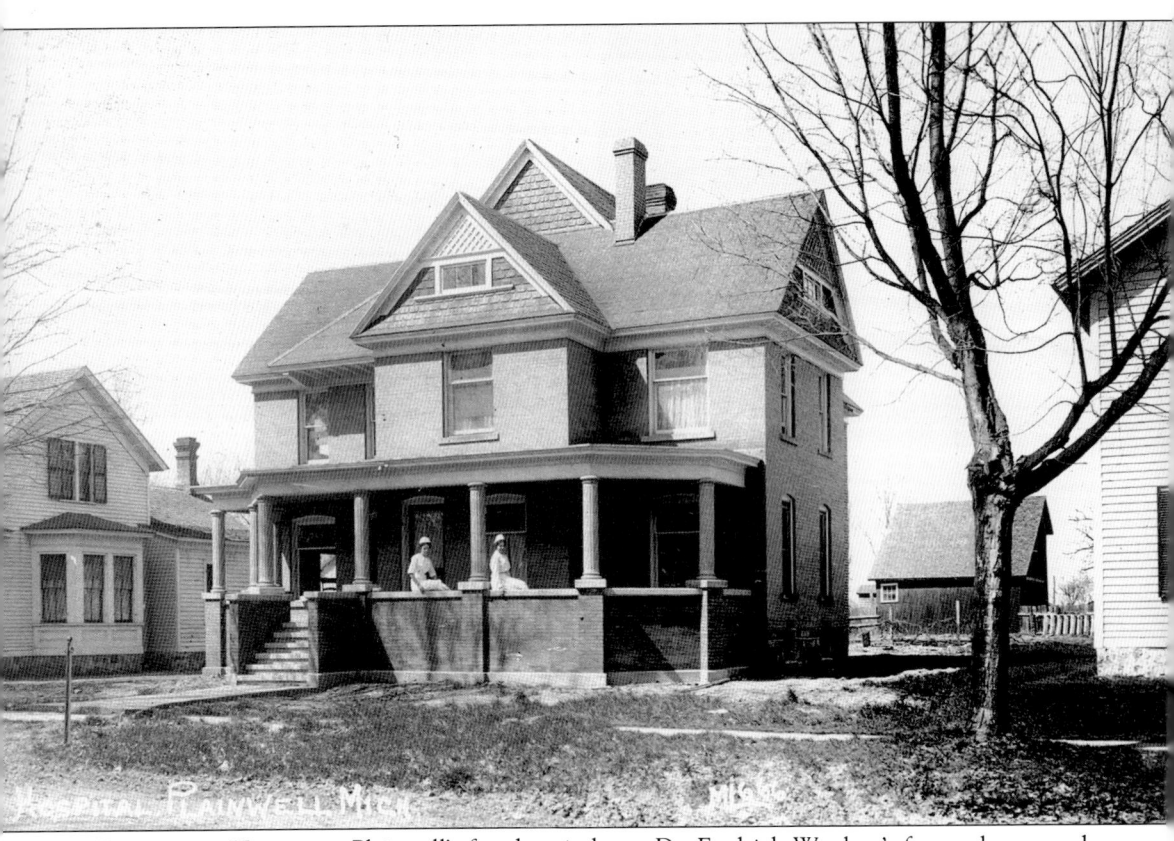

PLAINWELL HOSPITAL. Plainwell's first hospital was Dr. Fredrick Woolsey's former home and office. It was moved from Hicks Park to its present location at 408 South Main Street. Notice that the old porch was removed before the house was transported. A new brick porch now adorns the hospital. Today this is a private residence.

On the cover: OTSEGO SOAP BOX DERBY RACE. Racing down North Farmer Street toward downtown was a thrill for both parents and kids during the soapbox derby races of the 1940s and 1950s. This happy scene probably includes the winners for that year's event. From left to right are Jerry Burd, Charlene Jones, and Hal Hewitt. (Courtesy of the Otsego District Library.)

IMAGES of America
OTSEGO AND PLAINWELL

Ryan Wieber and Sandy Stamm

Copyright © 2006 by Ryan Wieber and Sandy Stamm
ISBN 978-0-7385-4116-7

Published by Arcadia Publishing
Charleston SC, Chicago IL, Portsmouth NH, San Francisco CA

Printed in the United States of America

Library of Congress Catalog Card Number: 2006932985

For all general information contact Arcadia Publishing at:
Telephone 843-853-2070
Fax 843-853-0044
E-mail sales@arcadiapublishing.com
For customer service and orders:
Toll-Free 1-888-313-2665

Visit us on the Internet at www.arcadiapublishing.com

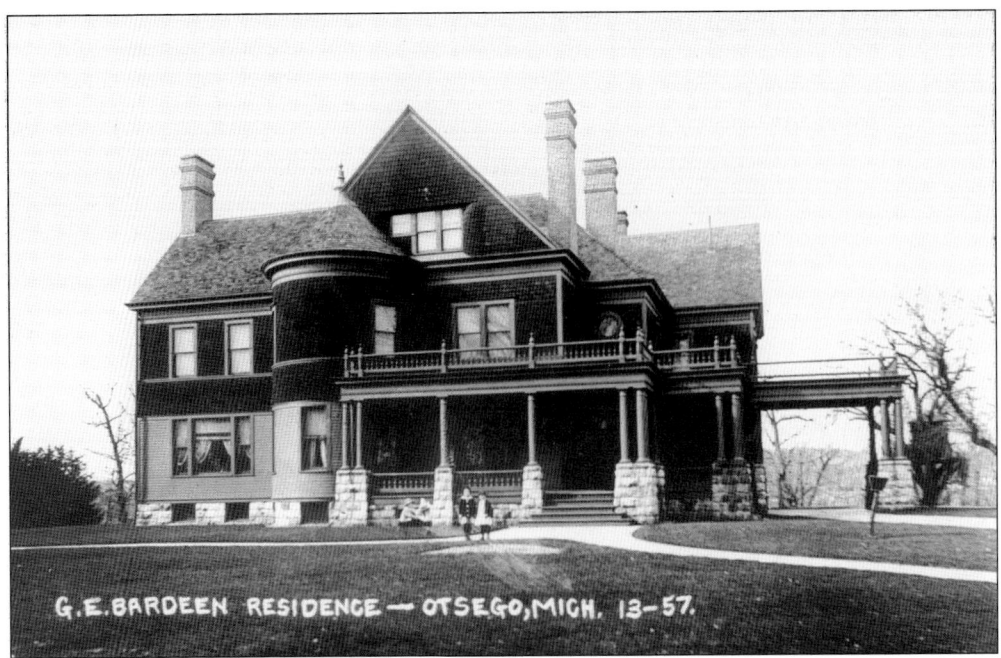

BARDEEN HOUSE. Owned by the founder of Otsego's paper mill industry, George Bardeen, this 1895 mansion once stood on West Allegan Street. It was heated by steam that was tunneled from the Bardeen No. 2 mill. The 21-room house came complete with a ballroom, a bowling alley, and a caretaker's residence. Voters in the city turned down a proposal in December 1955 to purchase it for the city's use. Eventually torn down in 1964, it still remains Otsego's most-talked-about piece of architecture. (Courtesy of the Otsego District Library.)

Contents

Acknowledgments 6

Introduction 7

1. Downtown Scenes 9

2. Business and Industry 23

3. Transportation 45

4. School and Church 59

5. Paper Mills 85

6. Disasters 99

7. Recreation and Leisure 113

Acknowledgments

This book could not have been produced without the amazing amount of local history research conducted by longtime resident Dorothy Dalrymple (1910–1995). Her dedication to preserving history for both communities was unending. I would also like to thank the Charles A. Ransom District Library for providing access to their local history files and archival photographs. Over the years Lucille Kortes has contributed many photographs for use in Plainwell research, and her willingness to share is appreciated. In addition, I would like to thank my proofreaders Nancy Stamm and Sue Hutchinson. All non-credited Plainwell photographs are from my personal collection.

—Sandy Stamm

Creating a photographic history of our communities would never have been possible without the help of so many that came before us. I'm thankful for the early photographers and those who preserved their work. I'm grateful for Dorothy Dalrymple, Ed Goodsell (1910–2004), his dear wife Frances, and all others who remember stories and love to share those stories. Their work will always carry on. A special thanks goes to Nancy Boettcher, Neta Nowak, and Al and Virginia Bronson for their help in making sure I got the facts right. I'd be remiss to not mention the terrific staff of the Otsego District Library who put up with me and my project. Thank you Brenda, Judy, Kathy, Kim, Sue, Angela, Adam, Meghan, Michelle, Donna, and Sarah! Finally, the biggest chunk of gratitude goes to my wife, Molly, who endured and encouraged with a big smile, and to my little ones Ben, Sophie, and Matthew who still recognize my face.

—Ryan Wieber

Introduction

Plainwell and Otsego are twin cities located in southwest Michigan on State Highway 89 separated only by a few miles of fast-food restaurants and chain stores. Their history is filled with interesting people, colorful stories, and of course—because of their close proximity to each other—an intense rivalry in all things, especially sports. The first gridiron match-up between the two high schools occurred in 1896, and since then every contest in every sport has always been heated! The rivalry can be seen off the field as well. Community pride mixed with a healthy dose of rivalry often leads to voiced opinions on which town has the better shopping, parks, industries, or school system. The census takers in 2000 did not make things easier when they counted the same number of inhabitants for each city—3,933—therefore negating the "we're bigger than you" thought.

Of course, if one "crosses over" to the other side and dares to live or raise a family in the neighboring town, then a good amount of initial disbelief and ribbing will ultimately be followed by acceptance. It happens all the time because with all of the rivalry there is also an understanding that both towns actually have a lot in common. Since their respective beginnings, Plainwell and Otsego have shared their families, workplaces, churches, morning coffees, salon and barber visits, and of course, opinions. The story of Plainwell would not be complete without the story of Otsego and vice versa.

Otsego began in the fall of 1831 with the arrival of the Samuel Foster family of Vermont. With a big financial boost from land developer Horace Comstock of New York, the village quickly grew. Comstock was married to the niece of James Fennimore Cooper. With his money, ambition, and family influence, he was able to convince the Michigan Territory's legislature to grant him the ability to build a dam on the banks of the Kalamazoo. This he did by 1836 along with a hotel, a store, and two mills.

Comstock eventually faded from the scene, but his time and effort in Otsego led to the growth of a town that still bears his vision for a place with wide streets, attractive commerce, and a community centered on the Kalamazoo River.

In the 1830s, a few brave pioneers settled two miles north of what is now Plainwell, obtaining land grants from Pres. Andrew Jackson. It was not until the Plank Road Highway was built in 1852–1855 on an early Native American trail between Kalamazoo and Grand Rapids that this area became more populated and a village began to emerge.

The settlement known as the Junction was surveyed in 1863, and in 1869, the village fathers petitioned Lansing, Michigan's state capital, to be incorporated as a village, naming the community after the Plainwell House Hotel. Plainwell is known today as the Island City because it is completely surrounded by the Kalamazoo River and an 1856 millrace.

This book does not set out to be a thorough history of our communities, but we hope it provides an interesting glimpse into the past. We have had wonderful historical resources to use, and the most difficult decision over and over was what had to be excluded from the book. This area is very fortunate to possess a rich abundance of publicly available photographic and archival material at Plainwell's Ransom District Library and the Otsego District Library. We hope this book inspires you to be aware of your historical surroundings wherever you may live.

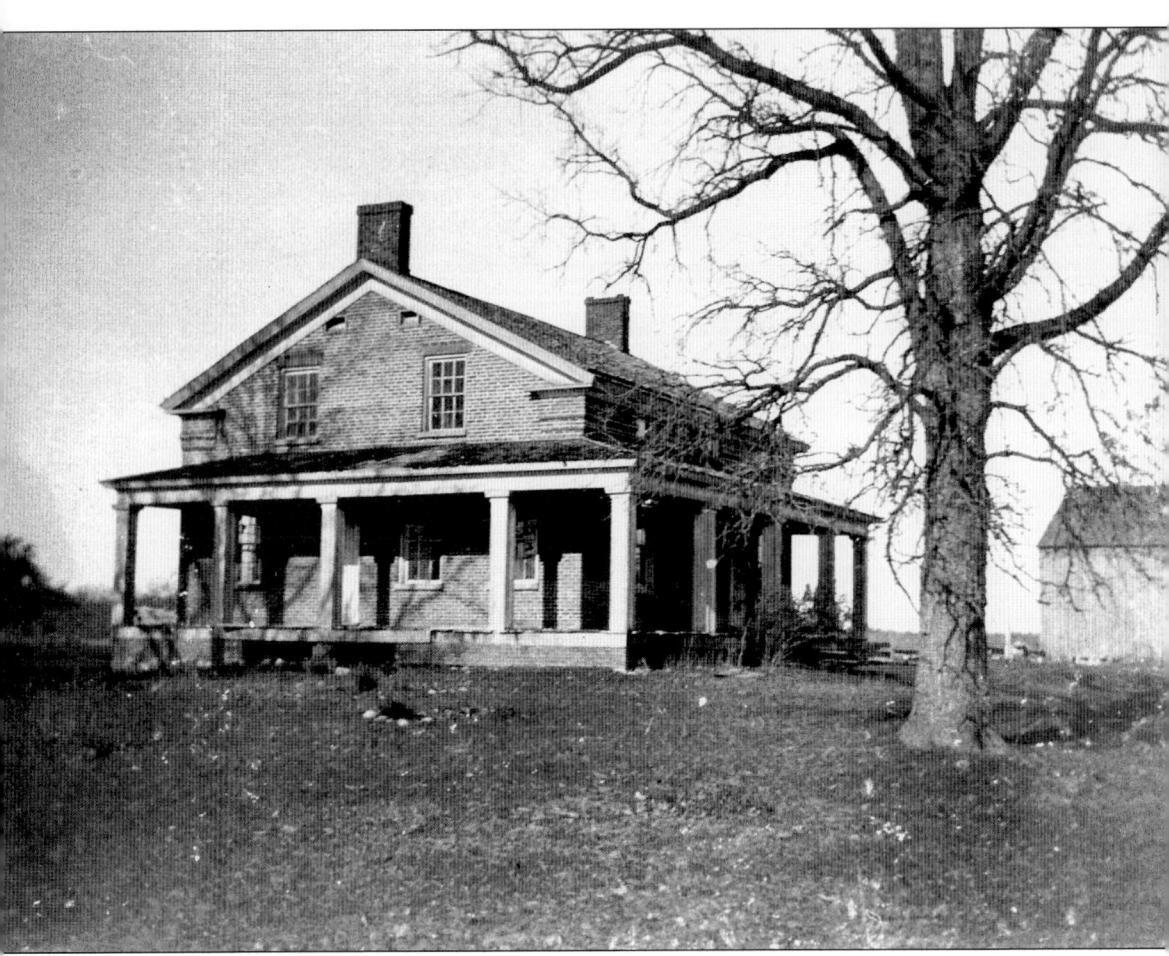

THE RED BRICK HOUSE. Calvin White built his Greek Revival–style house in 1838. This building is the oldest brick structure in Allegan County and has a long history of service to the area. Early in Plainwell's history, it was used as a stagecoach stop. Charles Richards purchased the property in 1928 and opened it as a public restaurant using the land for a garden nursery named Richards Gardens.

One
DOWNTOWN SCENES

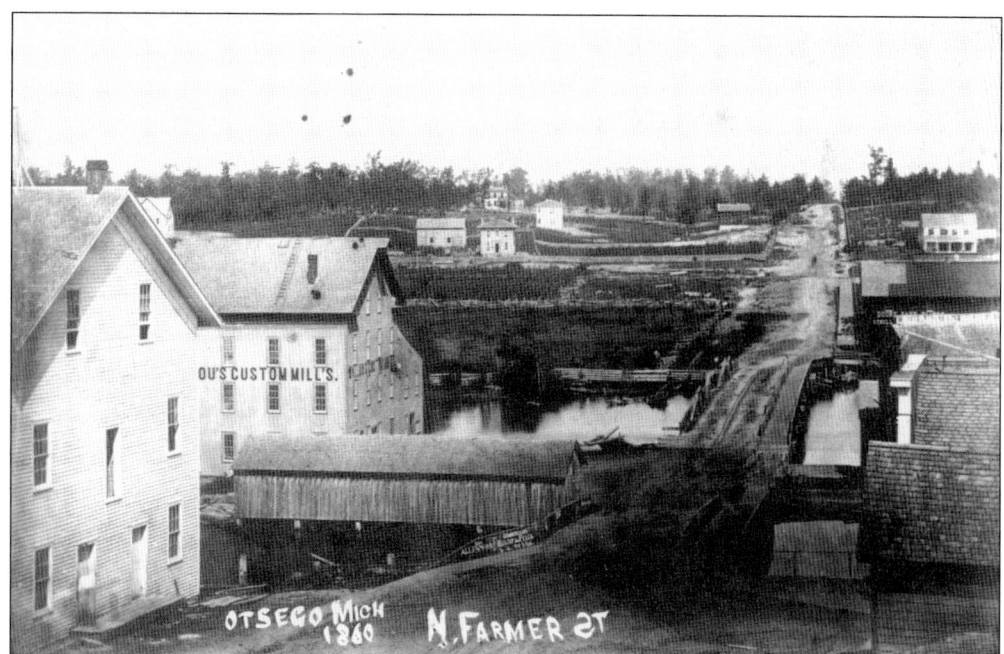

NORTH FARMER STREET, 1860. This view is looking north along Farmer Street and is the earliest known photograph of Otsego. Ballou's Custom Mills sits on the west side of the street in between the millrace and the river. The Italianate-style homes in the top center of the photograph were the beginnings of a desirable part of town known as the Highlands. Barely visible at the top right is the new Mountain Home Cemetery. (Courtesy of the Otsego District Library.)

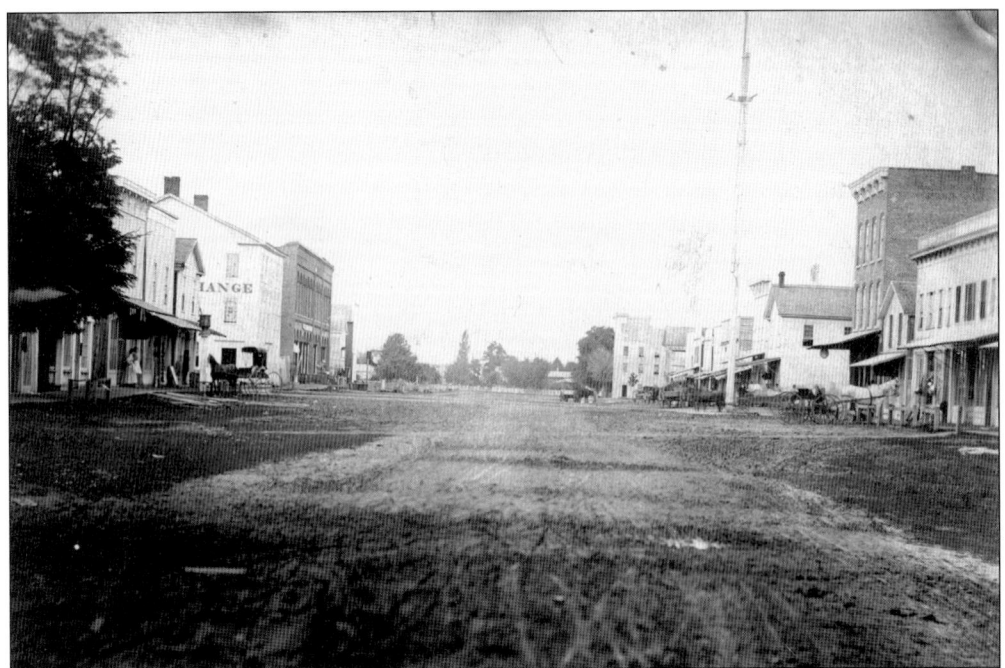

OTSEGO, 1868. The town's streets have been extra wide since its beginning in order to handle the anticipated amount of traffic that would come to a great commercial center. The commerce never fully developed as hoped by Horace Comstock, but the road width has always been appreciated by its travelers. The liberty pole was moved from the four corners to the Mansfield Lawn at East Allegan and Fair Streets in the 1880s. (Courtesy of the Otsego District Library.)

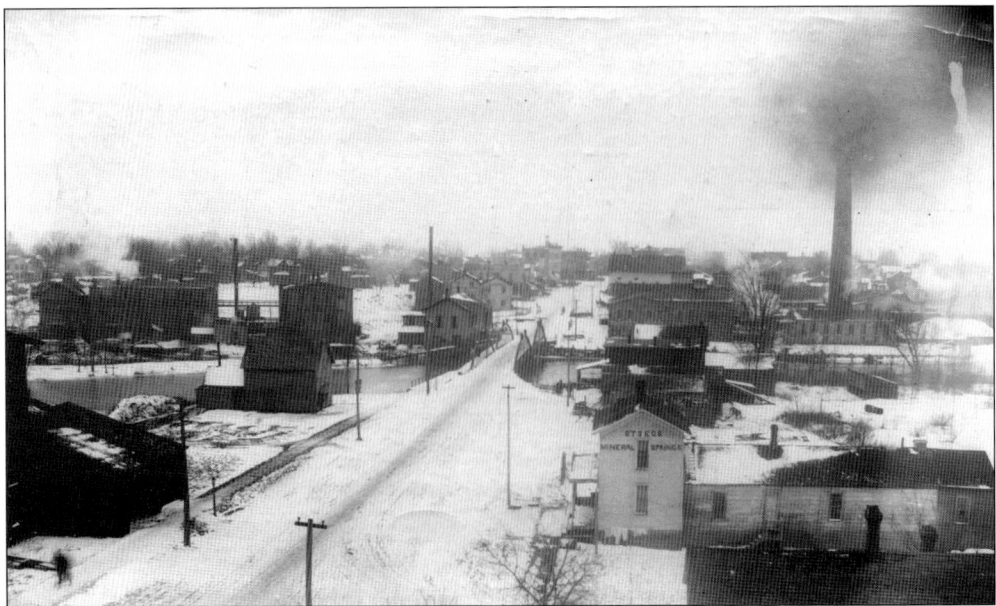

NORTH FARMER STREET, C. 1900. Perched atop the third floor of the Hotel Revere, the photographer captured the view of Farmer Street looking south. Shown here are the Mineral Springs Bathhouse, several buildings belonging to the Otsego Chair Company, and Bardeen Paper Mill No. 2. (Courtesy of the Goodsell family.)

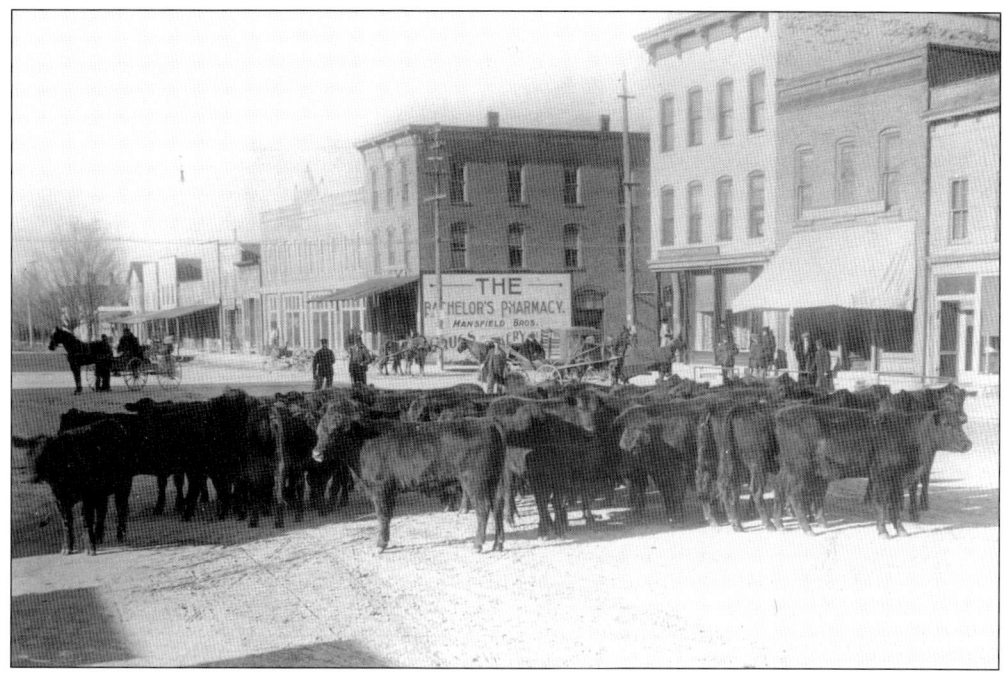

CATTLE ON ALLEGAN STREET, C. 1910. Fred Jewell's business was to ship produce and livestock to various local markets and Chicago by train. In this scene, Jewell is driving a herd of cattle from a local farmer to the freight depot on the northwest side of Otsego. He paused in front of the studio of photographer George Campbell to have the moment captured. (Courtesy of the Otsego District Library.)

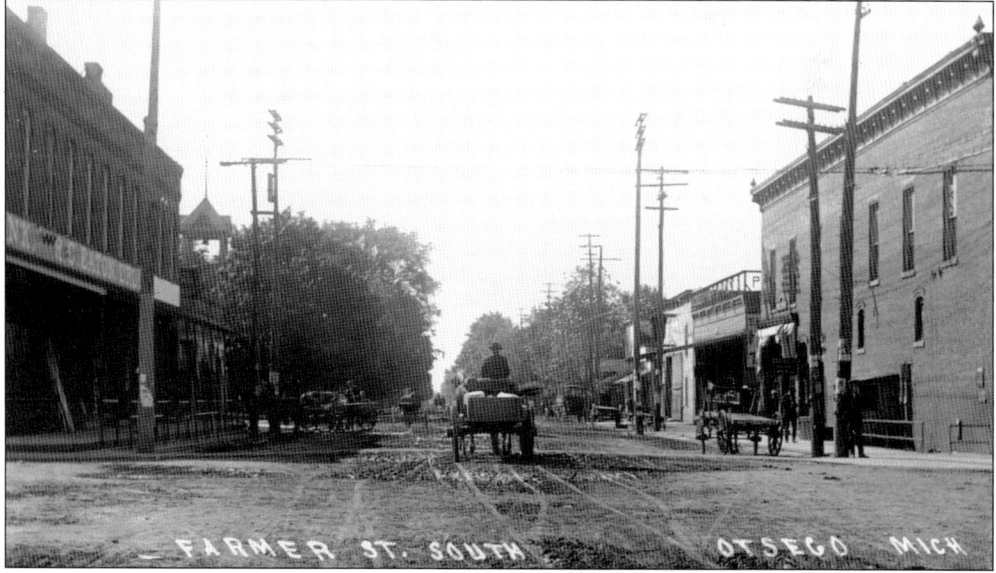

SOUTH FARMER STREET, 1910. Looking south from the main four corners in downtown Otsego, one would have seen the Edsell block and the Eaton drugstore to the left. Further south and on the left was the bell tower for the 1906 fire station. The series of buildings on the right included Marcia Hall's shoe store, the post office, dentist and law offices, and a harness shop. (Courtesy of the Otsego District Library.)

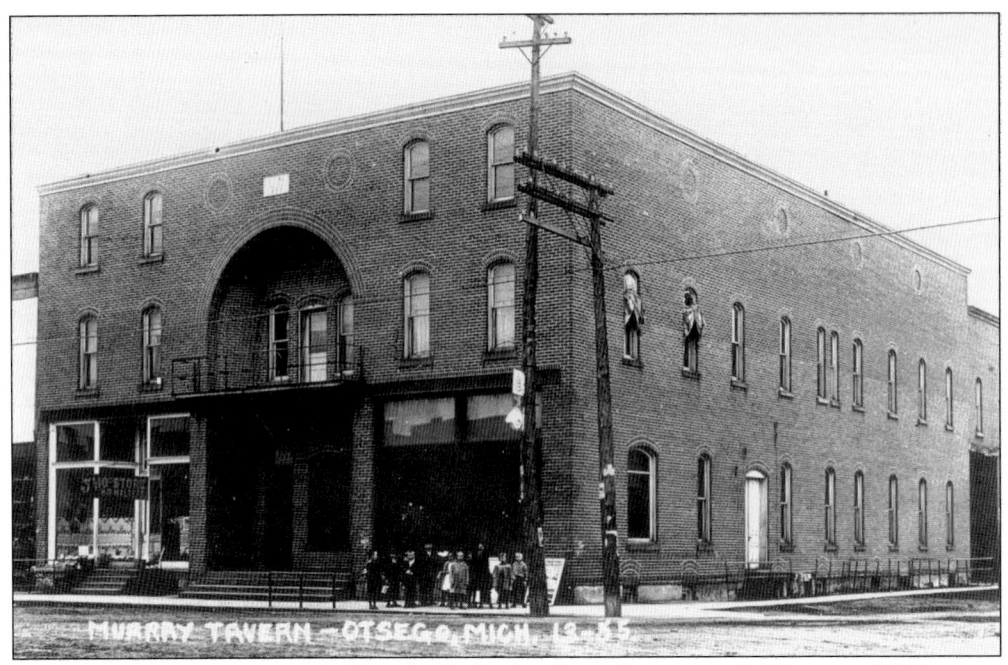

MURRAY TAVERN, 1906. D. A. Drew built this hotel on the corner of Allegan and Kalamazoo Streets in 1898. Originally called the Hotel Drew, he sold it in 1906 to Paul Murray who opened a restaurant and tavern on the site. He refurnished many of the rooms and kept the hotel business. By the 1920s, the name had changed to the Otsego Tavern. (Courtesy of the Otsego District Library.)

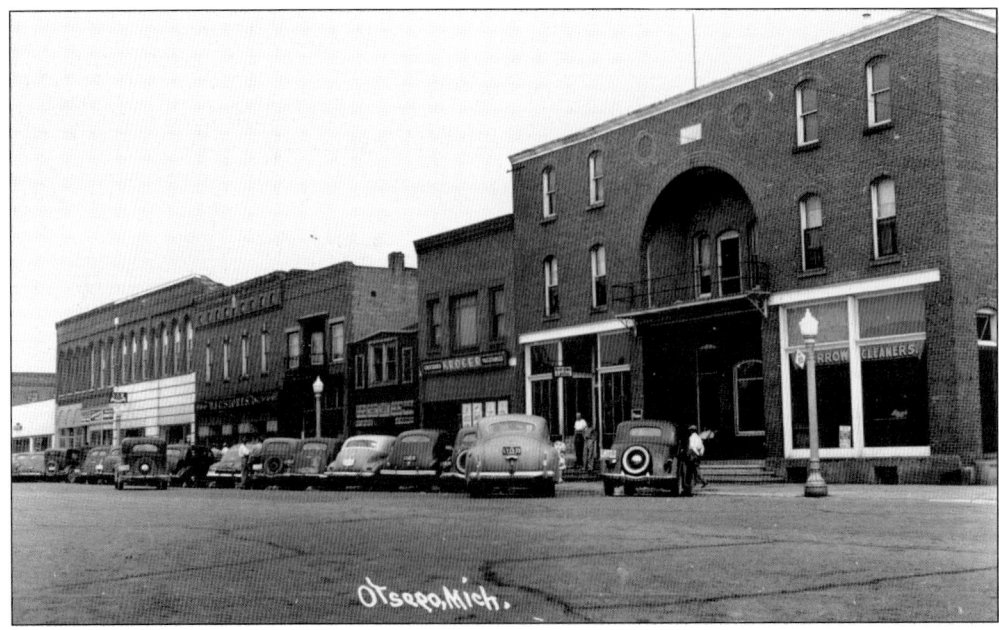

WEST ALLEGAN STREET, 1944. This south side view shows the old Hotel Drew. By this time, however, the hotel no longer existed, and the upper floors contained nine apartments. The block held two grocery stores including a Kroger, a restaurant, and a D. and C. Store. Notice the number of parked cars, indicating a busy business district. (Courtesy of the Otsego District Library.)

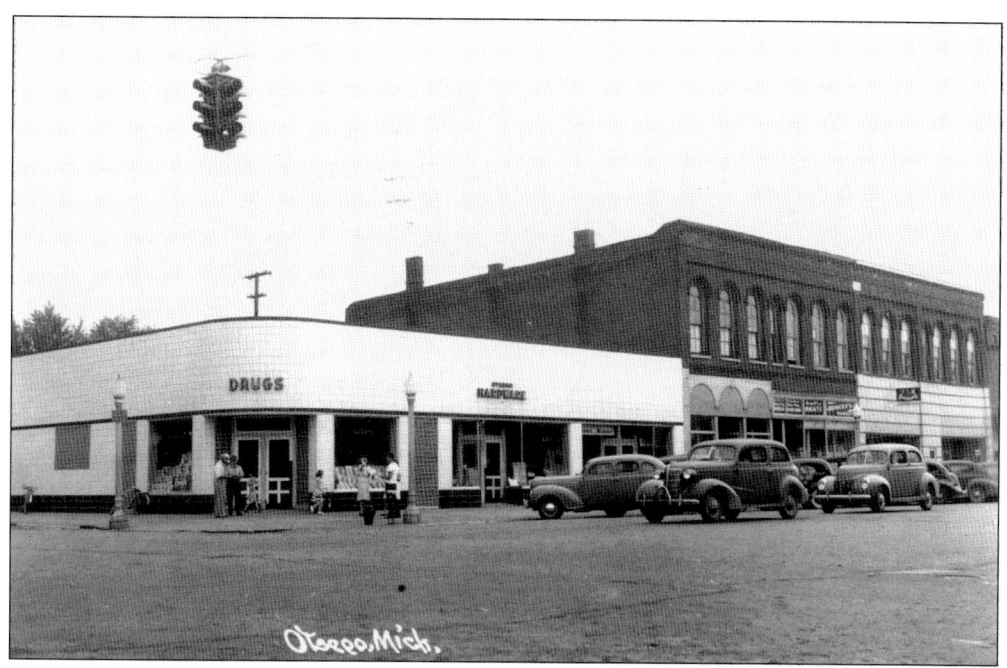

SOUTHEAST CORNER OF ALLEGAN AND FARMER STREETS, 1944. The Exchange Hotel sat on this corner from 1837 until 1899, when Eber and Gorham Sherwood built a newer two-story block. That building burned to the ground in November 1941 and was soon replaced with the white-tiled building currently standing today. Coburn's Drugs and Otsego Hardware occupied the corner for several years. (Courtesy of the Otsego District Library.)

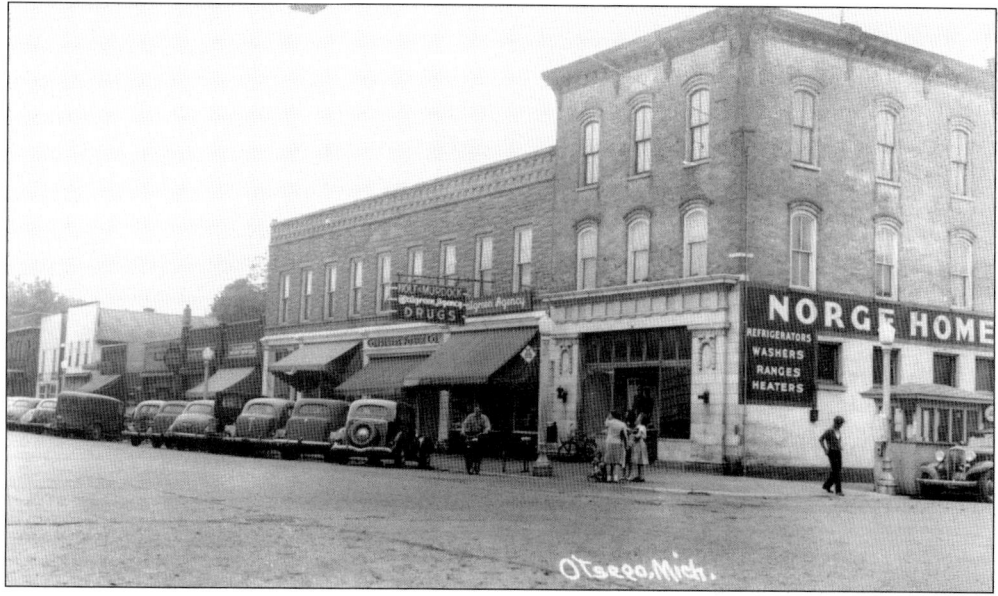

NORTHWEST CORNER OF ALLEGAN AND FARMER STREETS, C. 1942. Norge Home Appliances occupied this building constructed in 1889 by the Sherwood brothers. Citizens State Savings Bank did business there from 1914 to 1935, and in 1956 Kalamazoo Savings and Loan started a long run in that location. The top two floors were destroyed in a 1953 fire. Notice the small "police coop," or substation on the side of the road. (Courtesy of the Otsego District Library.)

OTSEGO POST OFFICE, C. 1935. Samuel Foster operated Otsego's first post office in the 1830s from approximately the same site where this gas station was situated on West Allegan Street. Ironically and nearly 80 years later the post office once again could be found on that same spot. Erected in 1914 by M. L. Stowe, the brick building shown here housed the post office until 1958. (Courtesy of the Otsego District Library.)

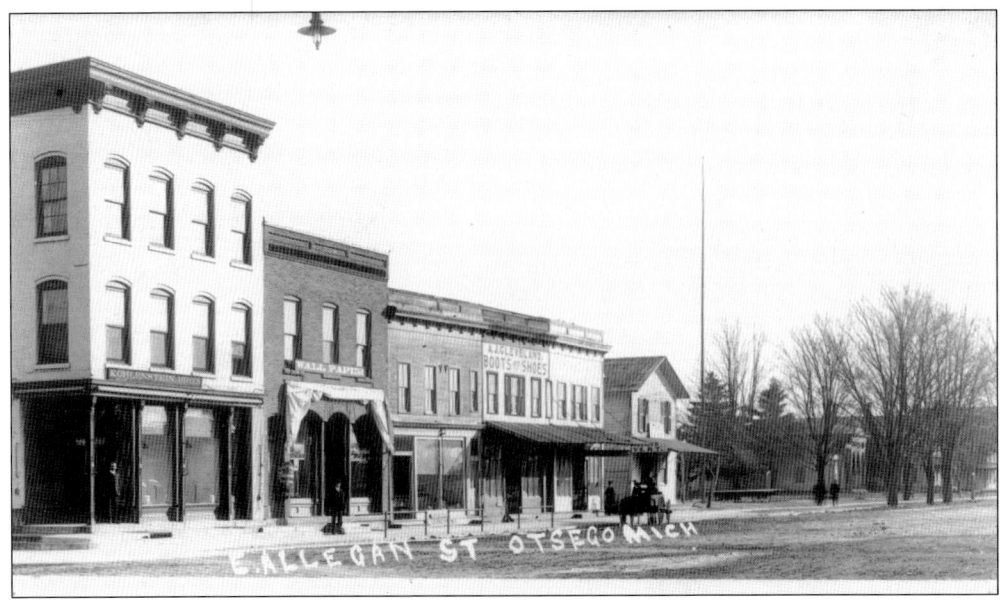

EAST ALLEGAN STREET, C. 1905. Built in 1854, the white building on the corner was referred to as the Mills Block, and from 1895 until 1922 it housed the Kohlenstein Dry Goods Store. The tall liberty pole in the picture was located on the Mansfield Lawn, a common gathering spot for rallies and concerts. (Courtesy of the Otsego District Library.)

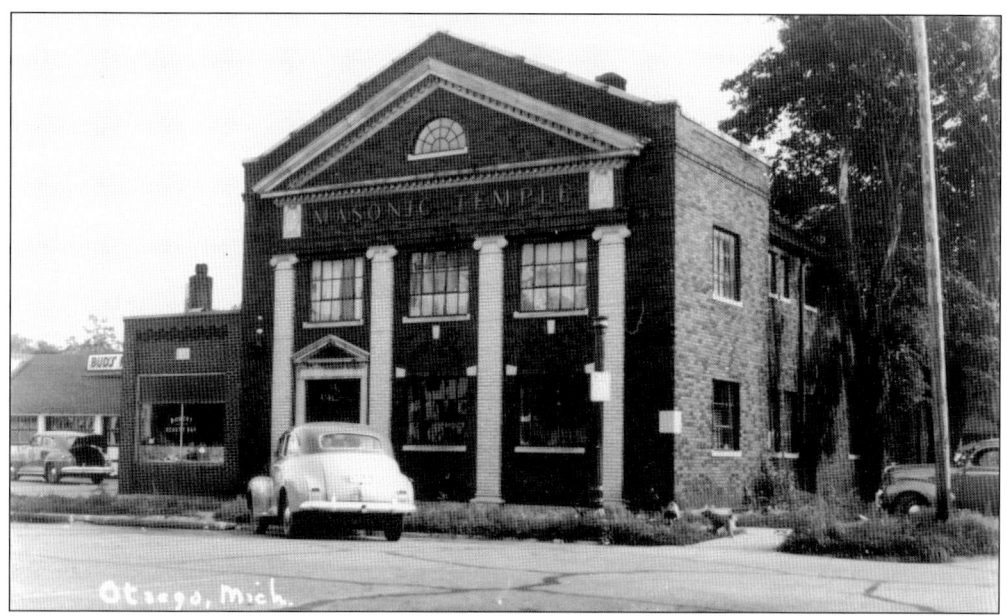

MASONIC TEMPLE, C. 1953. Since the founding of Otsego, the northwest corner of East Allegan and Fair Streets sat empty and acted as a community meeting place. It was known since the 1860s as the Mansfield Lawn. However, in 1930, the local Masons financed the construction of a new building at that spot. Bud McPherson's auto body shop can be seen at the far left. (Courtesy of the Otsego District Library.)

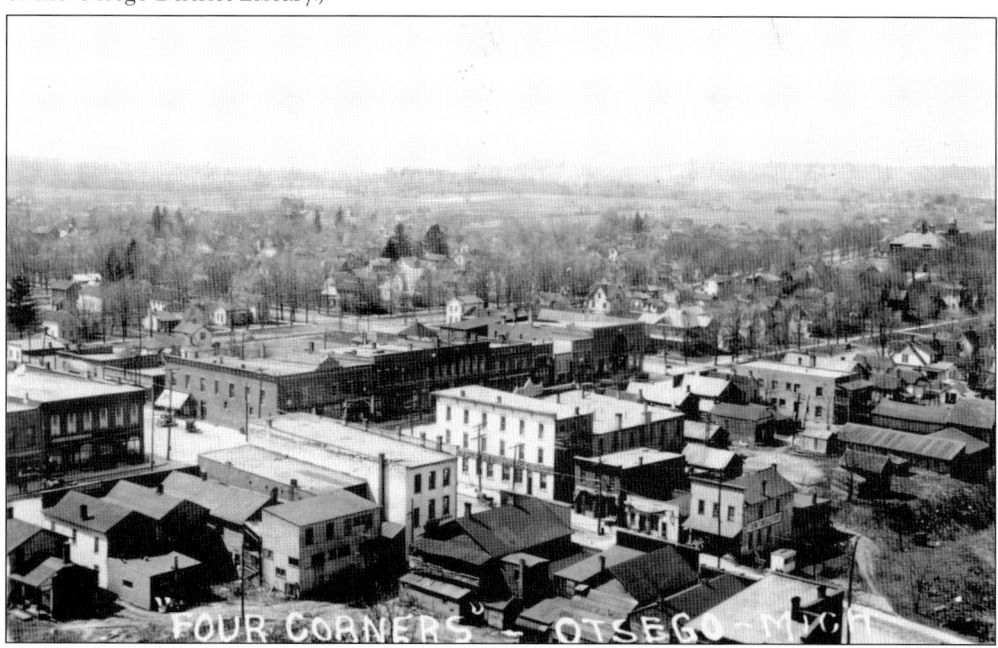

AERIAL OF DOWNTOWN OTSEGO, C. 1915. Compared to today's mostly one-story downtown buildings, this early-20th-century shot gives proof that long ago there existed many two- and three-story structures in Otsego. By examining closely, it is interesting to note the small amount of houses built on the west side of town. New plats would soon expand development in that direction. (Courtesy of the Otsego District Library.)

THE FLAT IRON. The flat iron was in the center of Plainwell and was called this because of its shape. West Bridge Street is on the left, and Allegan Street is the on the right. The back of this pie-shaped piece is Church Street. Before it became Hicks Park, many buildings, as pictured here, were located in this area. Even Plainwell's first little red schoolhouse was built there.

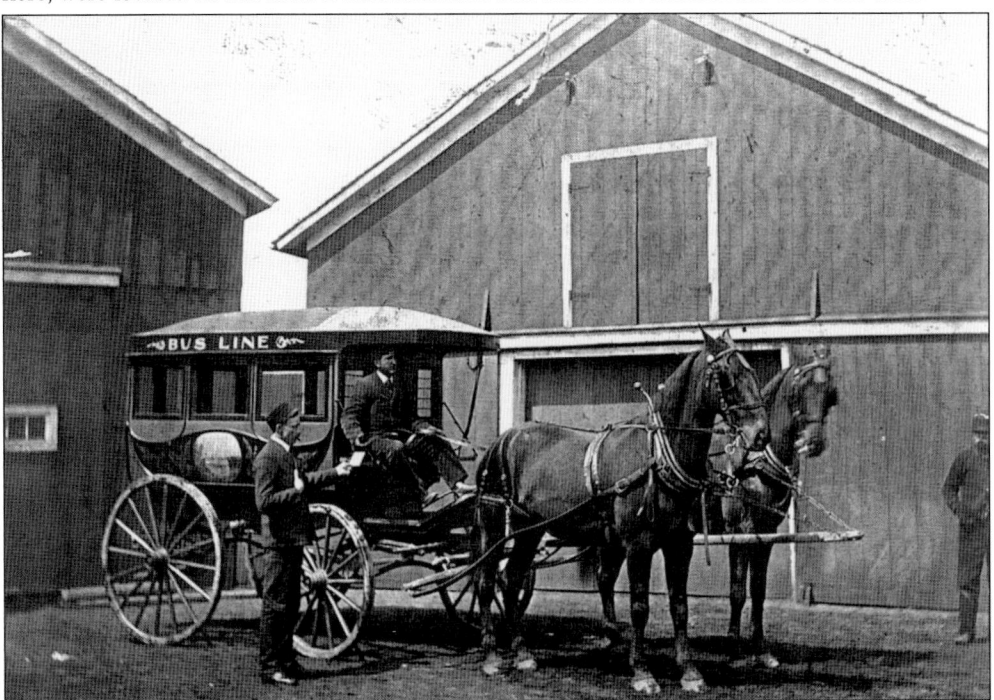

THE BUS LINE. The Bus Line taxi service took its passengers to and from the railroad depots, delivering some clients to the six hotels located in the village. The livery barns for this Bus Line service were located behind the buildings on the west side of North Main Street in what is now a parking lot for city hall.

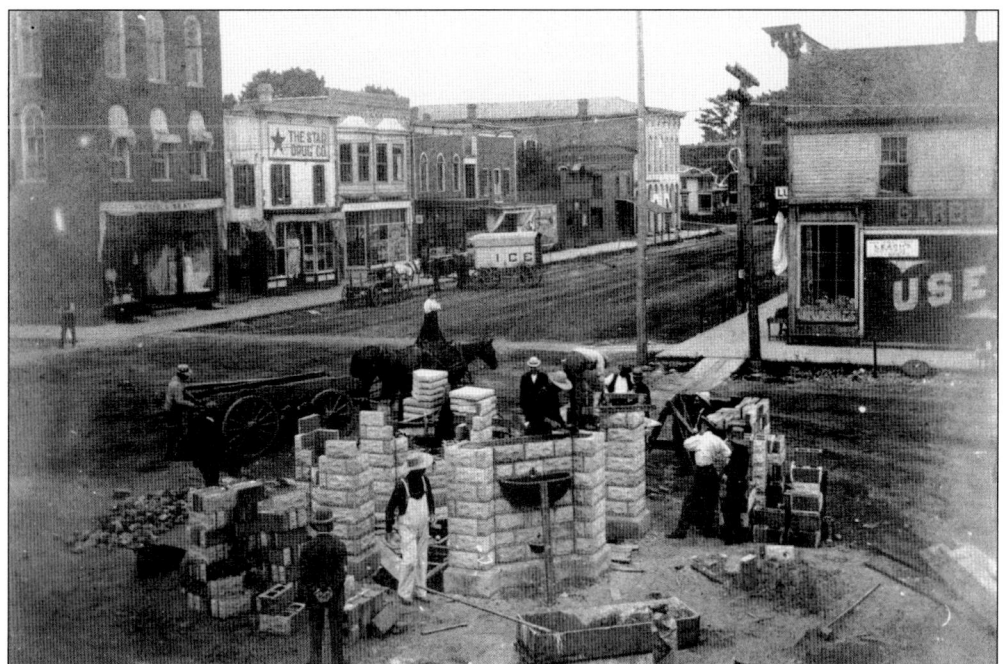

BUILDING THE FOUNTAIN. A Plainwell landmark, this fountain was donated and built by Carrie Soule in memory of her late husband, George Gary Soule. Here the brick masons are working hard at completing the project. It was finished just in time for Plainwell's first homecoming. Standing at the five-road intersection, it remained there for 46 years. (Courtesy of the Ransom Library.)

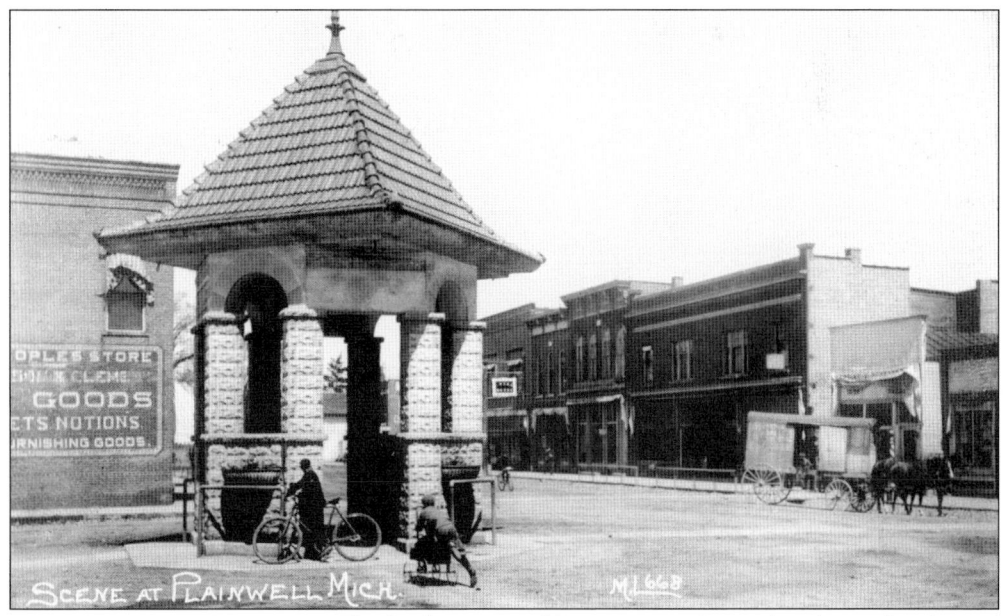

SOULE MEMORIAL FOUNTAIN. The Soule Memorial Fountain was located in the road in front of Hicks Park. This structure was 26.5 feet high, 16 feet in diameter, had brick facing, was octagonal in shape, and had a red tile roof. Inside, it had four drinking fountains. On the outside, there were drinking places for dogs and horses. Two boys have stopped at the fountain for a drink.

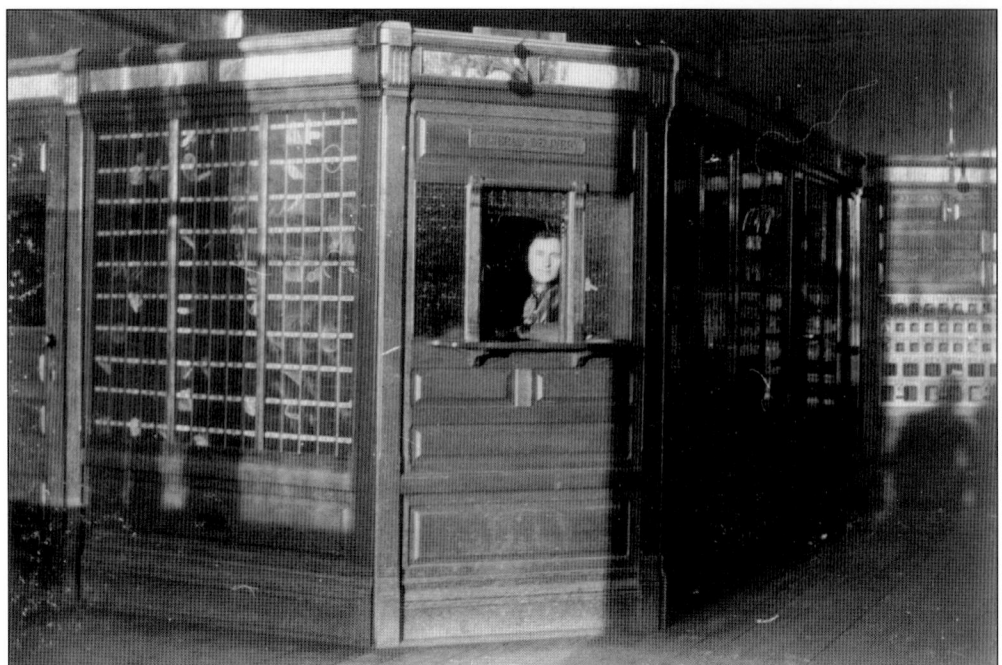

PLAINWELL POST OFFICE. This is an interior shot of the Plainwell Post Office located on the east side of North Main Street. One could only buy stamps and ship packages at the window. The village did not have local delivery until 1917, so the Plainwell citizens had to come to the post office for mail pick-up. Will Purdy was Plainwell's first village mail carrier. (Courtesy of the Ransom Library.)

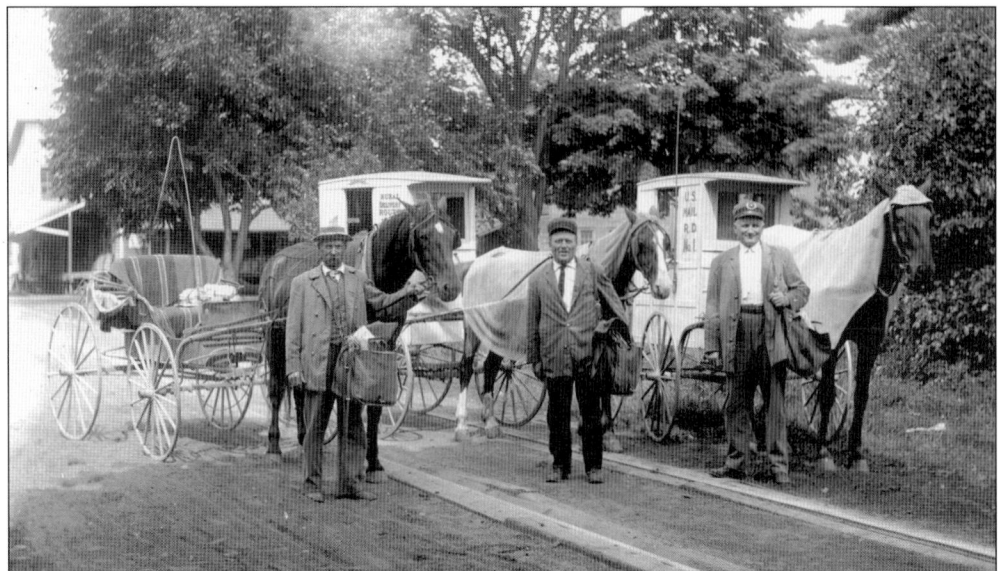

RURAL DELIVERY. Plainwell had rural mail delivery before it had local delivery. Cap Foreman was hired as the village's first rural delivery postman in 1900. Between 1900 and 1904, two other rural routes were added. David Burke and Ben Maude were appointed as mail carriers. Pictured in this photograph are, from left to right, David Burke, Ben Maude, and Cap Foreman. (Courtesy of the Ransom Library.)

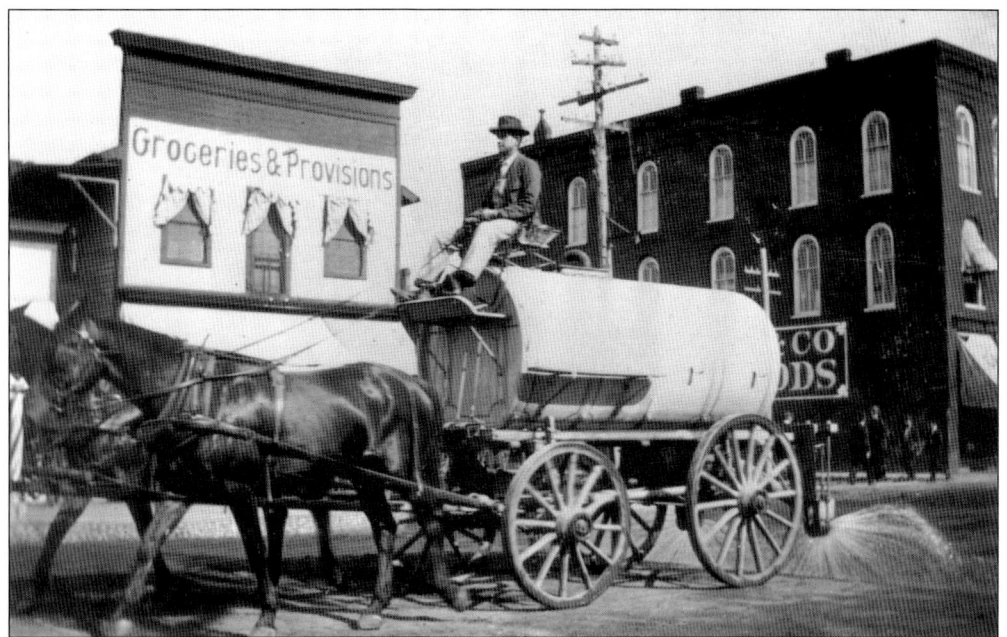

SPRINKLING WAGON. Sitting on top of the sprinkling wagon is John Price. Because the early roads were dirt, these sprinkling wagons helped to settle the dust. For a fee, Price would go in front of one's business or home and water the road. Lashers Groceries and Provisions and the Wagner and Heath Company Dry Goods Store are pictured in the background at the intersection of East Bridge and Main Streets.

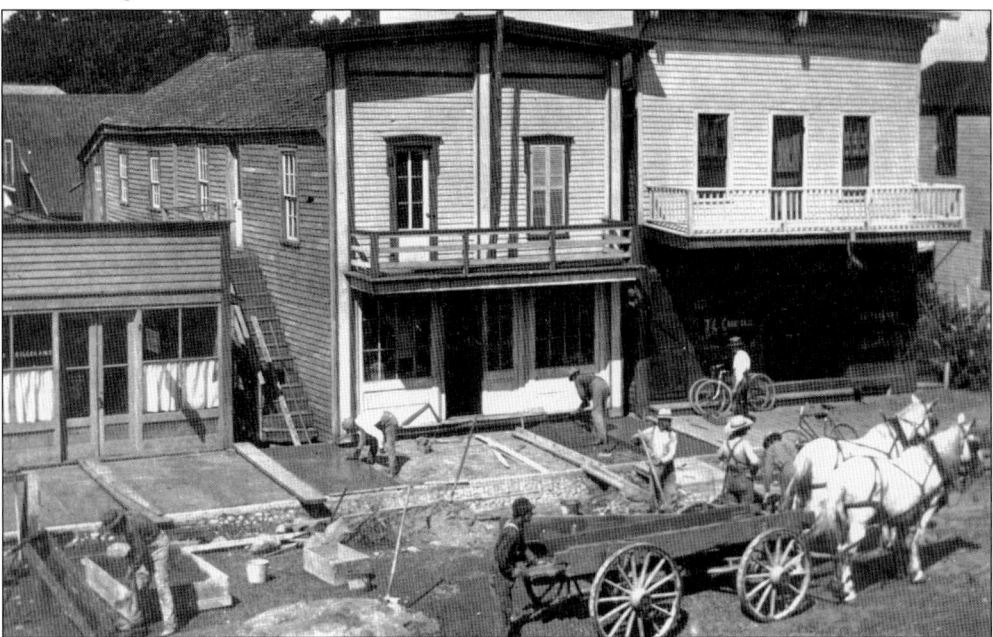

LAYING SIDEWALKS. Workers are replacing the boardwalk with cement sidewalks in front of the businesses on the west side of North Main Street. Buildings are, from left to right, Milo Chandler's Shoe Repair Shop, the Plainwell Enterprise print shop and office, and T. C. Carroll's Electrical Shop. Plainwell started laying cement sidewalks at the end of the 1800s.

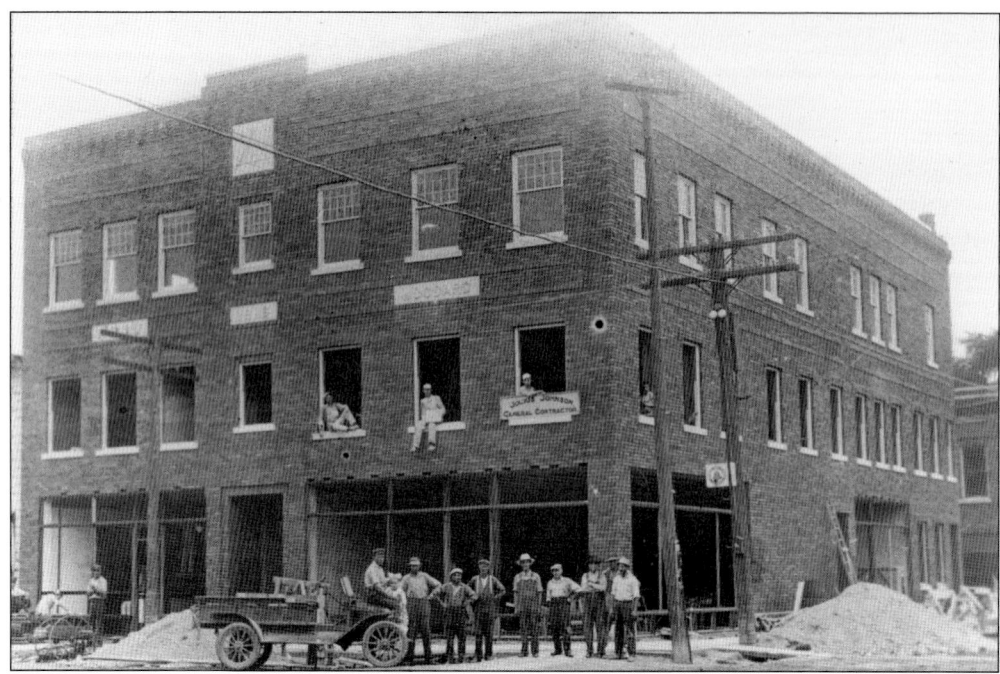

SPENCER WOODARD BUILDING. Shown here is the construction of the Spencer Woodard Building in 1916. While being built and only the sub-floor in place, a circus came to town. When the trainers were fording the elephants across the river, two escaped. One came to town and fell through the unfinished sub-floor, landing in the basement. The elephant was rescued by having it walk up a plank made from railroad ties.

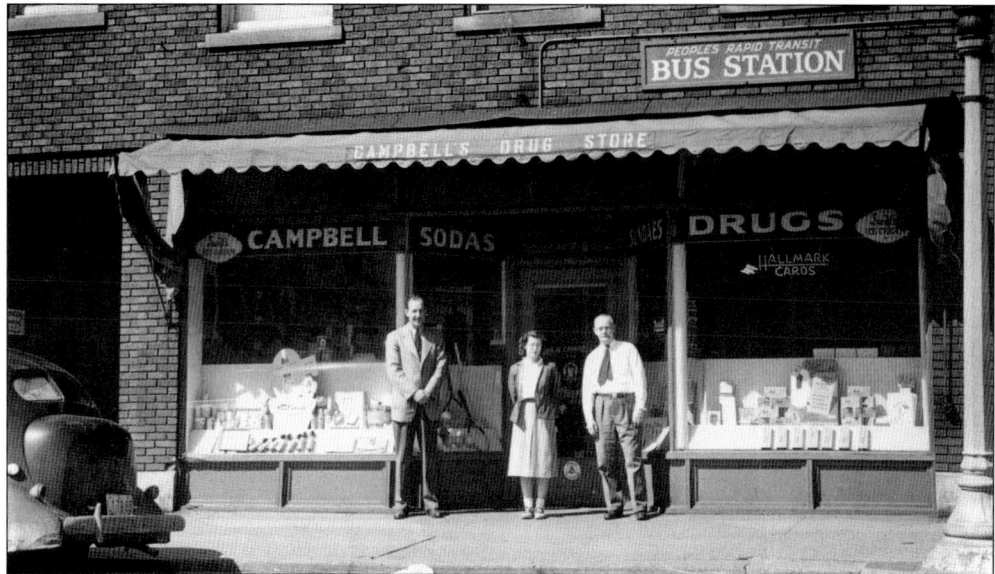

CAMPBELL DRUGS. The Campbell Drug Store in the Spencer Woodard building was located on the southwest corner of Main Street. Dr. Shipman's dental office was on the upper level of the building. The Greyhound Bus stopped at this location on its way to and from Kalamazoo and Grand Rapids. Residents in this 1948 photograph are, from left to right, owner Wayne Campbell and workers Barbara Blackmer and Harold Lent.

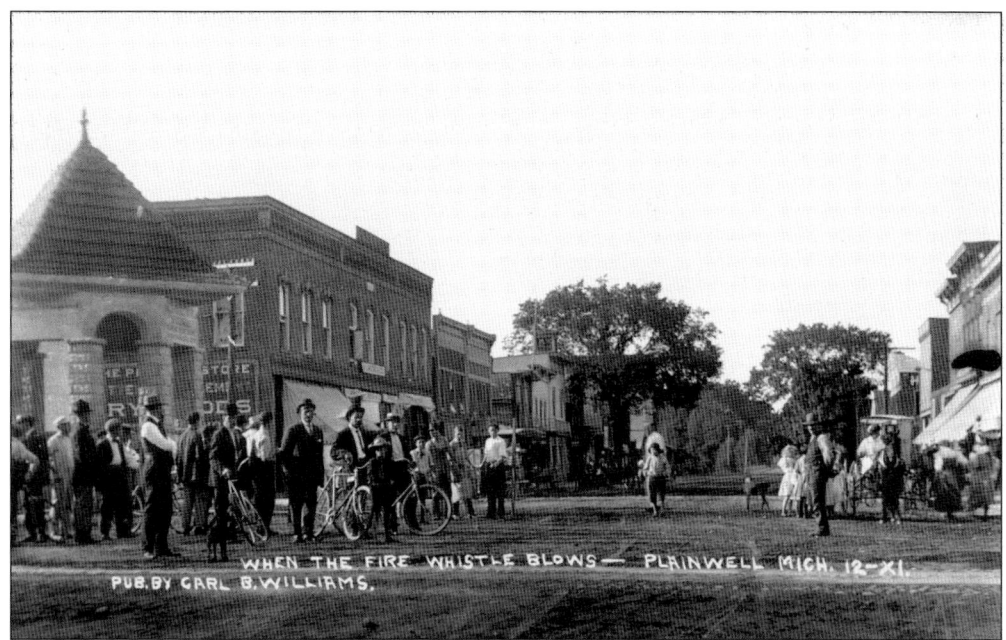

FIRE CALL. In this real-photo postcard, it seems that many of the village residents are congregating in the middle of Main Street. Notice the young gentlemen at far left, pulling the fire hose cart on their way to the fire. A dog, children, buggies, men with bicycles, and just people standing around all complete this scene.

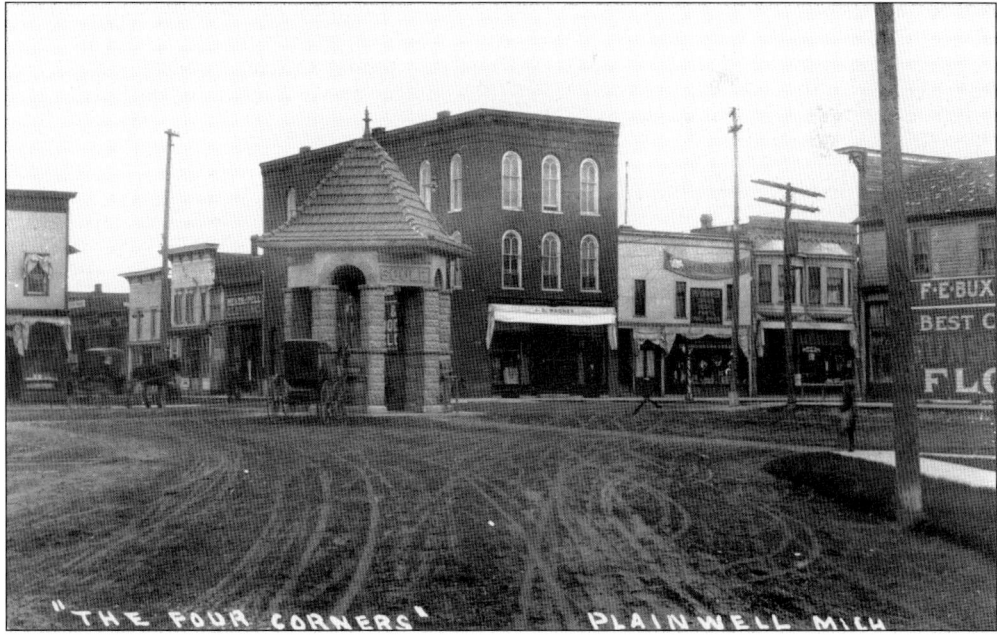

PLAINWELL'S FOUR CORNERS. The main four corners of Plainwell are shown here, East and West Bridge Streets, North and South Main Street, and Allegan Street. The wooden building on the right was replaced in 1916 with the Spencer Woodard building. Notice the horse drinking water from the Soule Memorial Fountain. This was its original purpose. When the automobile came along the fountain became a traffic hazard.

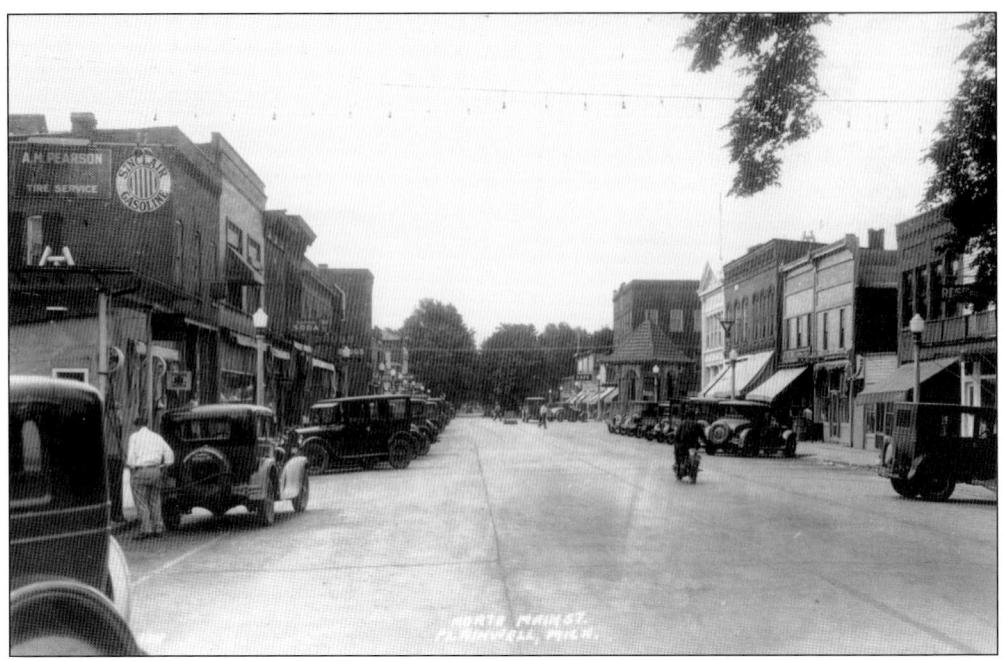

PLAINWELL'S NORTH MAIN STREET. This view is looking south from North Main Street in the 1930s. Even a motorcycle is on its way through town. The village seems to be very busy. At the left, the tire on the back of the automobile getting gas at Pearson's Sinclair Gas Station is advertising a local business, "Honeysett and Chamberlin."

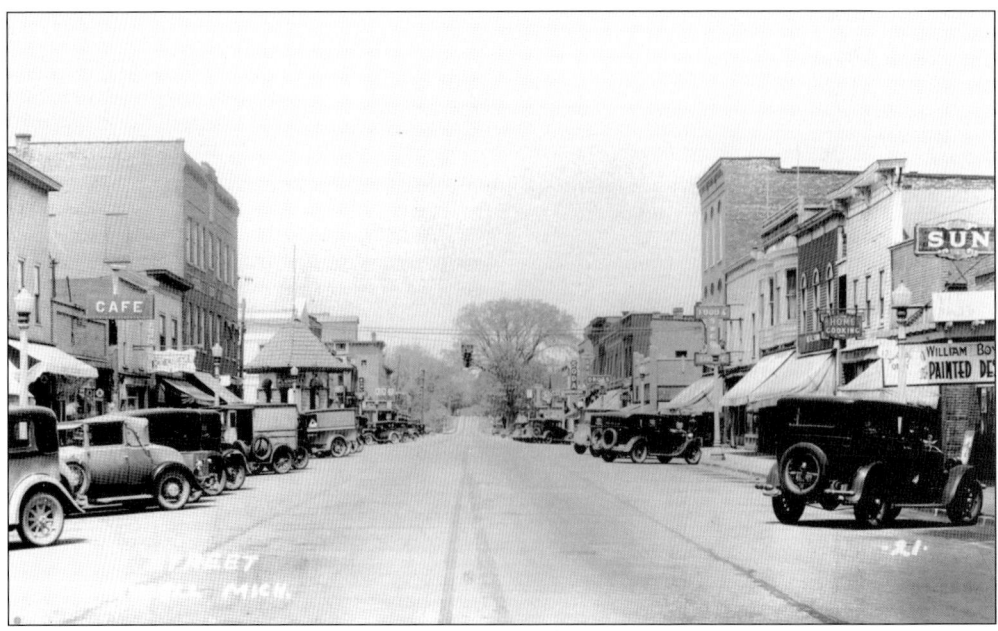

SOUTH MAIN STREET. It appears that the motion picture the *Painted Desert* starring William Boyd is playing at the Sun Theatre. It was another busy Saturday in town as automobiles line the streets. Plainwell's Soule Memorial Fountain, located on the left, appears in at least 80 percent of all of photographs taken of Plainwell's Main Street between 1907 and 1953.

Two
BUSINESS AND INDUSTRY

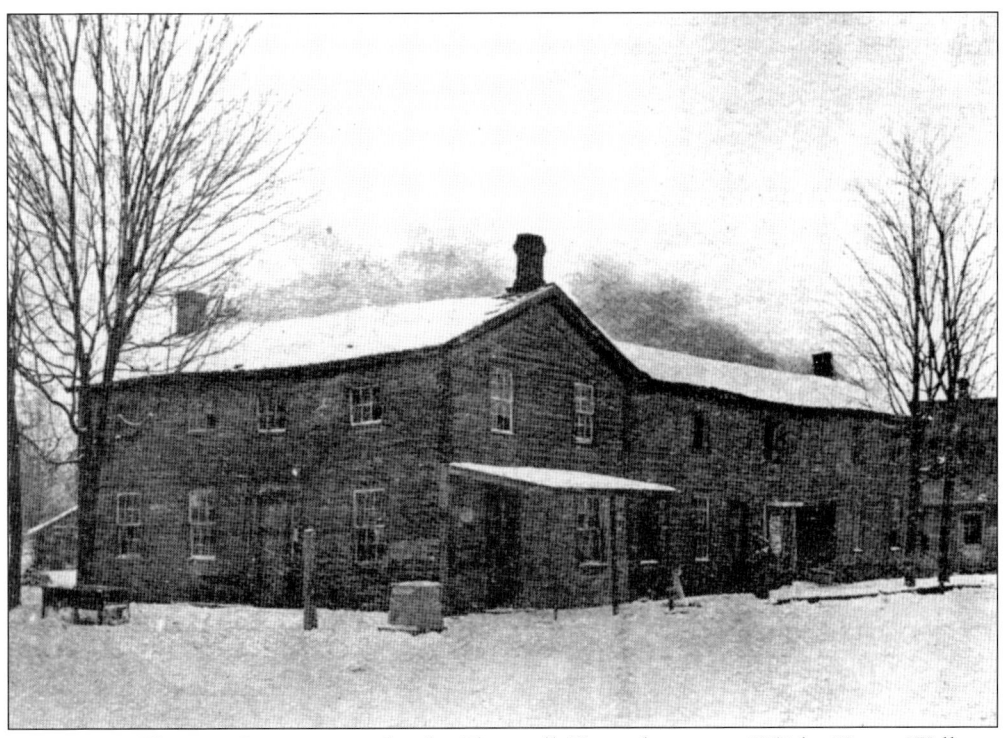

PLAINWELL HOUSE. Construction for the Plainwell House began in 1853 by Henry Wellever on the old Plank Road Highway. Orson D. Dunham came to the Junction from Eaton Rapids and bought land that surrounded the Wellever property. Dunham then agreed to purchase the unfinished Plainwell House. In July 1854, Plainwell's first business was opened to the public for dining, lodging, and entertainment under Dunham's ownership.

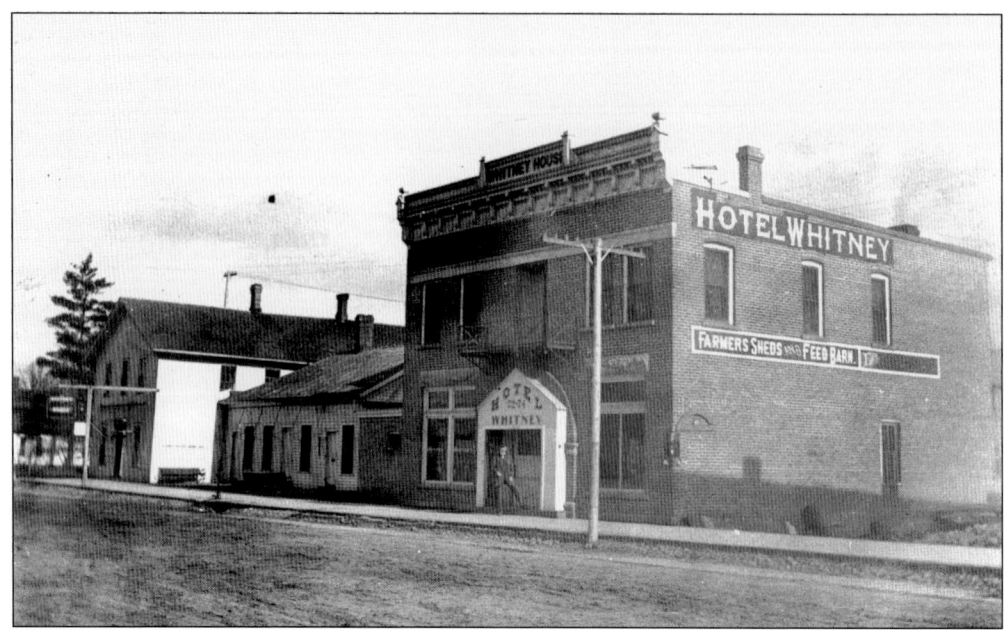

WHITNEY HOTEL. Early in Plainwell's history the village had five hotels to service the Plank Road Highway. The Whitney Hotel was located on the east side of North Main Street. This hotel was originally called the National Hotel and was built in the 1870s. Still being used in the 1930s, it was one of Plainwell's last surviving hotel buildings.

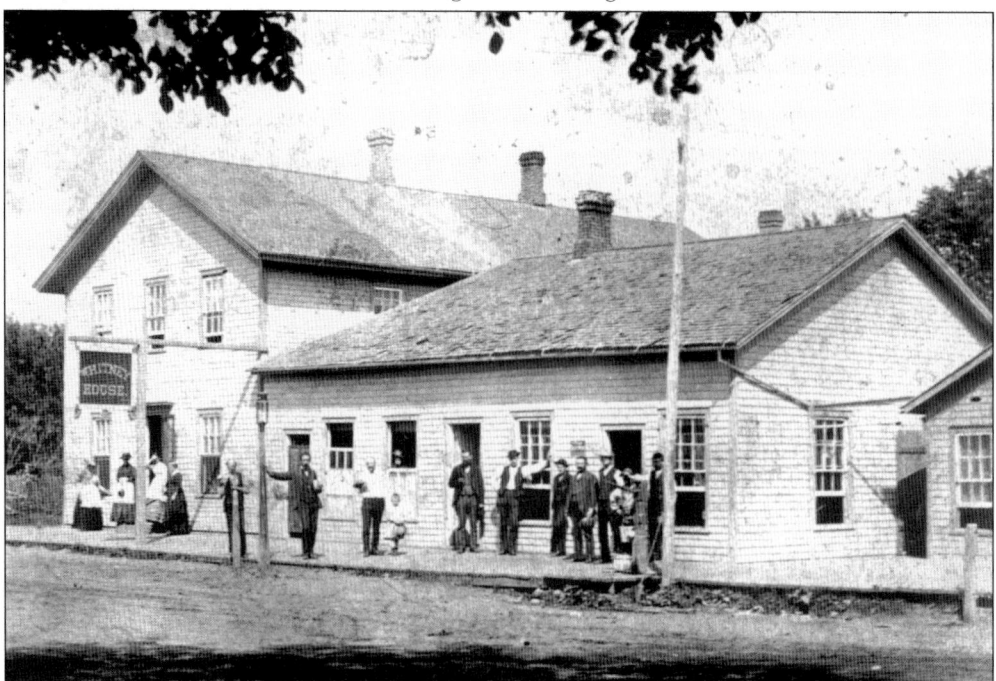

WHITNEY TAVERN. A subsidiary to the Whitney Hotel, this tavern was located just a few feet north of the hotel. It served food and drinks primarily to the hotel guests. Later this became Hudner's Boarding House. The building far left, shown in the photograph, became the Gardens Tavern. In 1986, the tavern was torn down to make room for an addition to Harding's Market.

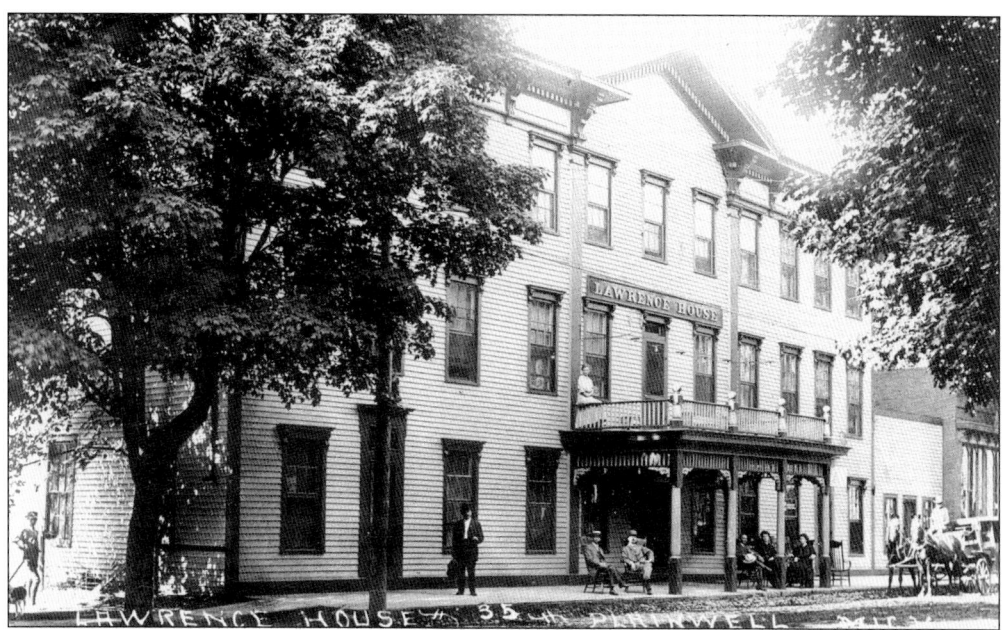

LAWRENCE HOUSE. The Lawrence House was built in 1874 by Lawrence and Herrick. The building was adjacent to the Plainwell Exchange Bank (Aries London Grill) on the south side of East Bridge Street. The magnificent hotel contained 21 rooms, a pool hall, a saloon, and a public hall on the third floor. In 1911, rooms rented for $2 per day. The building was demolished in 1930.

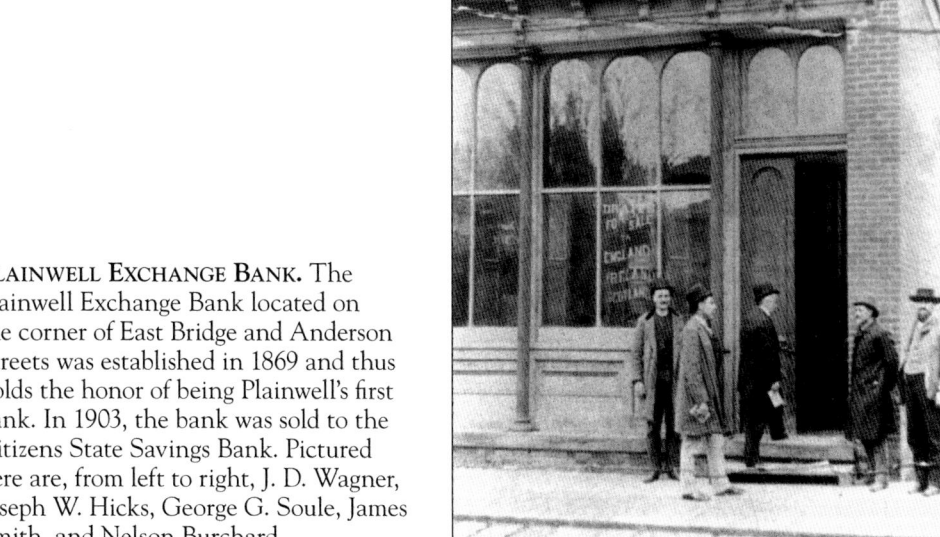

PLAINWELL EXCHANGE BANK. The Plainwell Exchange Bank located on the corner of East Bridge and Anderson Streets was established in 1869 and thus holds the honor of being Plainwell's first bank. In 1903, the bank was sold to the Citizens State Savings Bank. Pictured here are, from left to right, J. D. Wagner, Joseph W. Hicks, George G. Soule, James Smith, and Nelson Burchard.

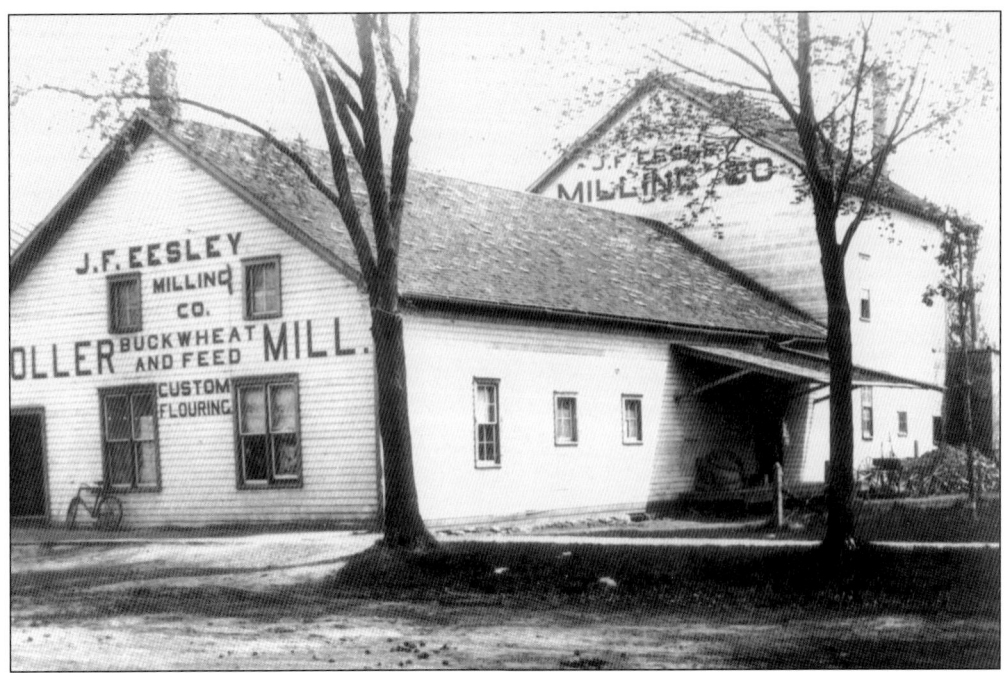

EESLEY MILL. John F. Eesley purchased the skating rink building on West Bridge Street in 1887 for his Buckwheat Mill. A campaign was organized in 1903 to make the flat iron a park. Eesley told Ingraham and Travis that he would trade his property on West Bridge for their property on the flat iron. With this acquisition, Eesley was then able to donate the land to the village for a park.

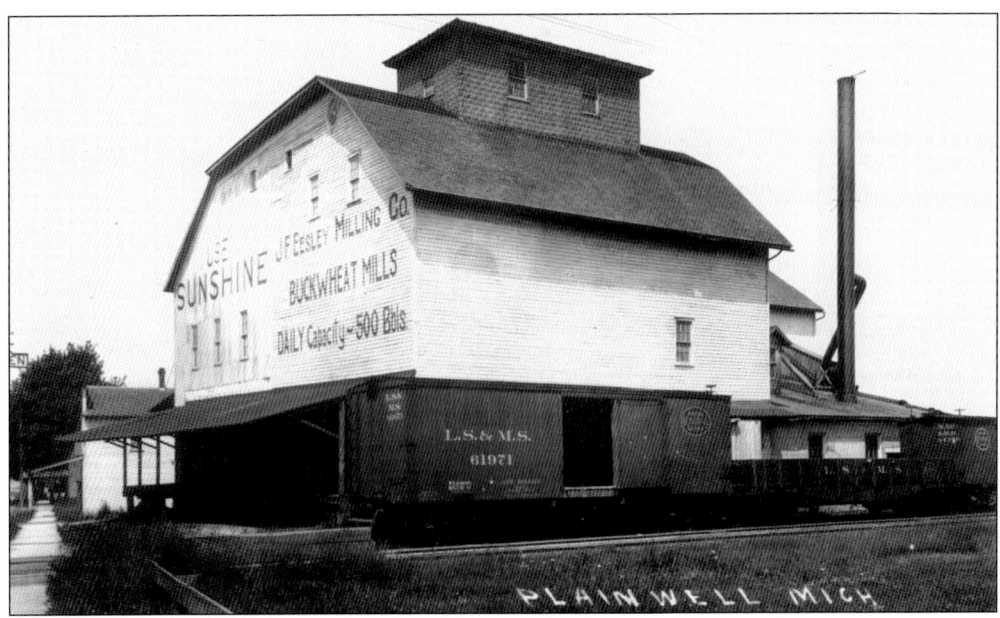

EESLEY MILL MOVED. In 1903, the John F. Eesley Mill was moved from the south side of West Bridge Street to the 700 block of East Bridge Street to make room for the new Ingraham and Travis building. Moving structures in Plainwell was a common practice during the early part of the 20th century. Eesley sold this mill to Lloyd E. Smith and Company in October 1932.

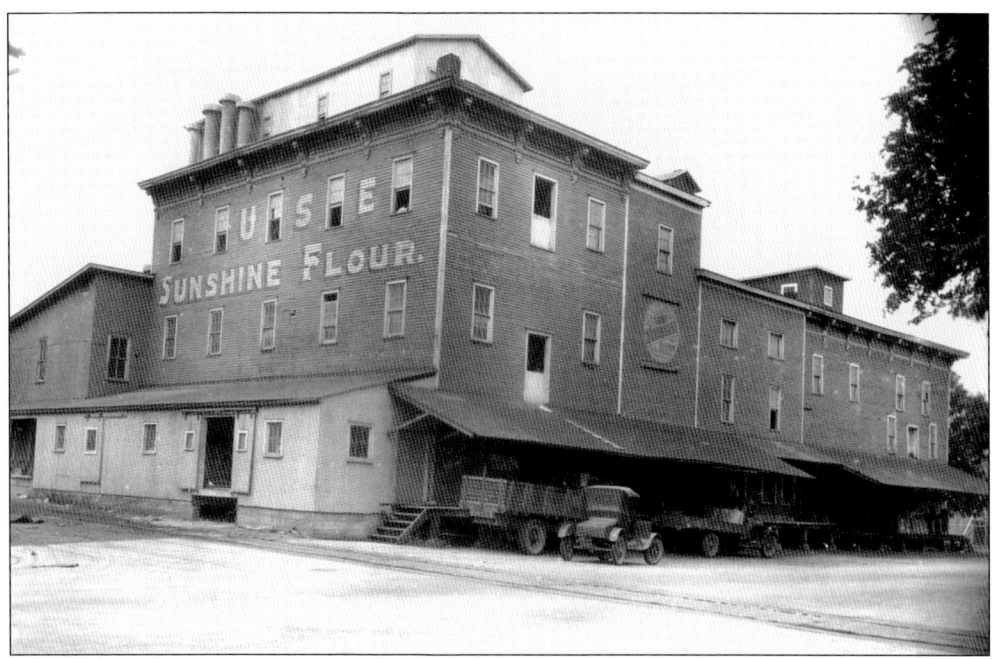

EESLEY SECOND MILL. With his success in the flour milling business on Bridge Street, Eesley decided to purchase the Merrill Mill property on Main Street. At an auction in December 1900, Eesley made the high bid of $4,000 and the building was his. This mill was destroyed by fire in June 1932.

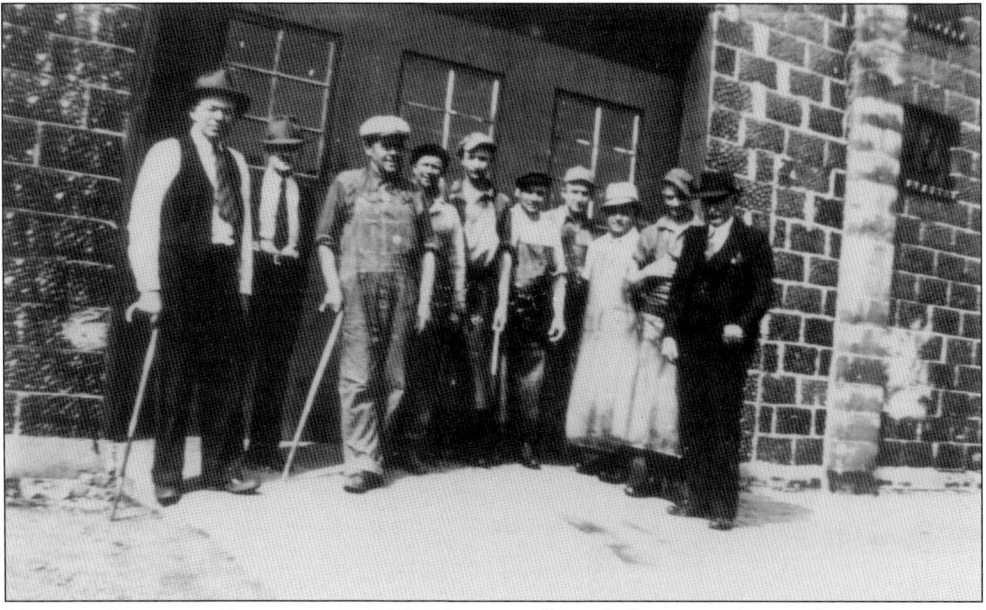

MURRAY PACKING COMPANY. Paul H. Murray and his father moved into the back part of the Woodard Building after purchasing the Kelly Meat Market in 1920. After eight years, the business moved its slaughter operation to Eleventh Street and the retail meat market two doors south. The retail business was eliminated and the slaughterhouse flourished. Murray, left, is shown with his employees. Today the business operates as Packerland.

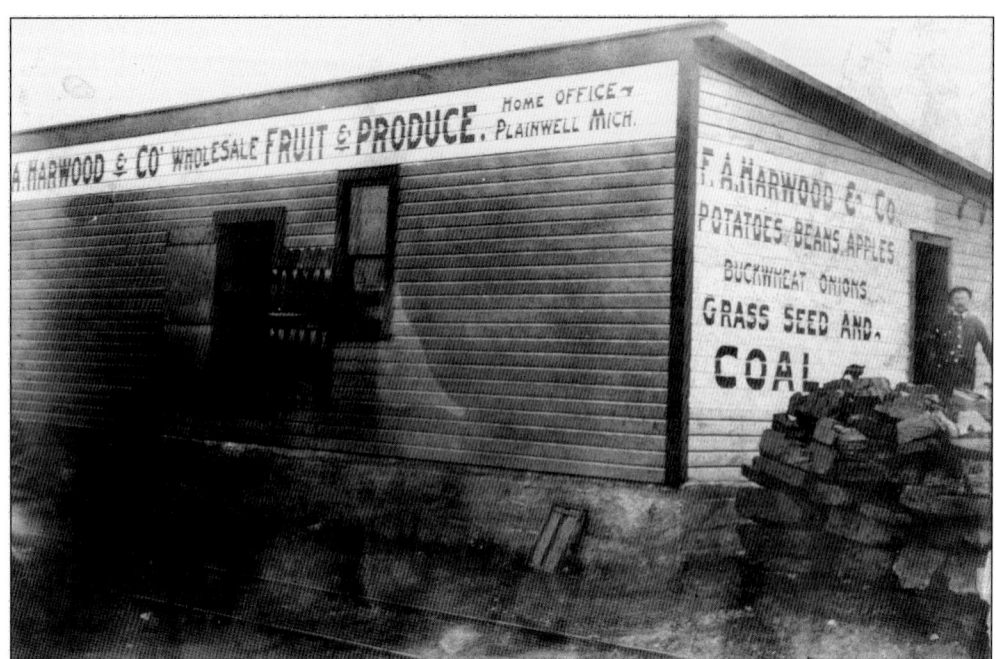

F. A. HARWOOD AND COMPANY. In the later part of the 19th century, the Harwood company was one of the largest shippers of produce locally. It was located on East Bridge Street next to the railroad tracks. The business was converted to a Farmers Co-op in 1919. Valley Metal purchased the structure in 1954 and had it demolished, making it possible for a new structure to be built in its place.

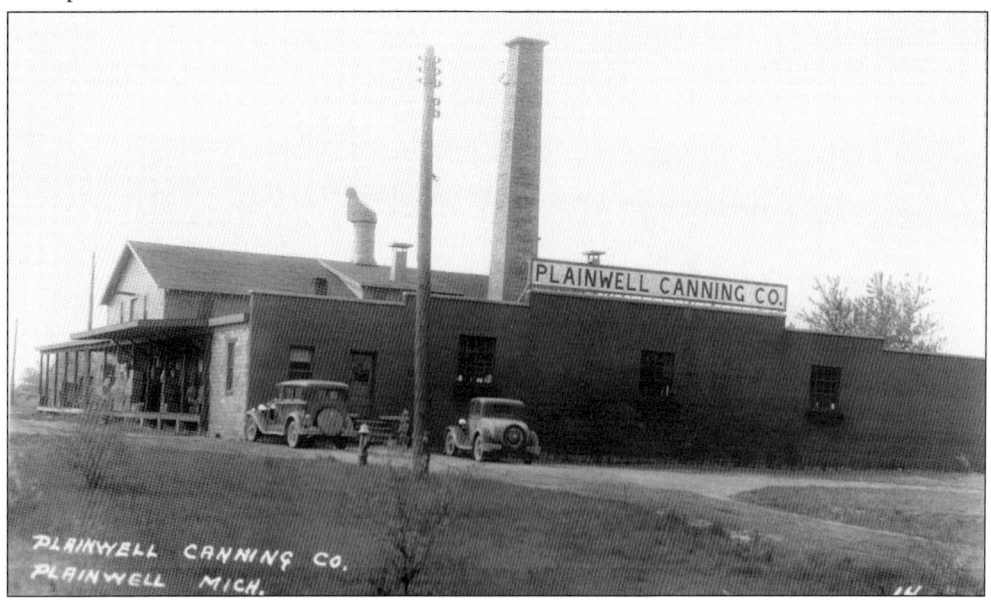

PLAINWELL CANNING COMPANY. The Harwood brothers, Herman and Dwight, organized the canning company just prior to World War I under the Harbro label. William R. Pell purchased the company from the brothers in 1924. The following year he doubled the size of the plant and tripled the capacity for canning and packing fruits and vegetables. The majority of employees working in the company were women. Pell retired in 1947.

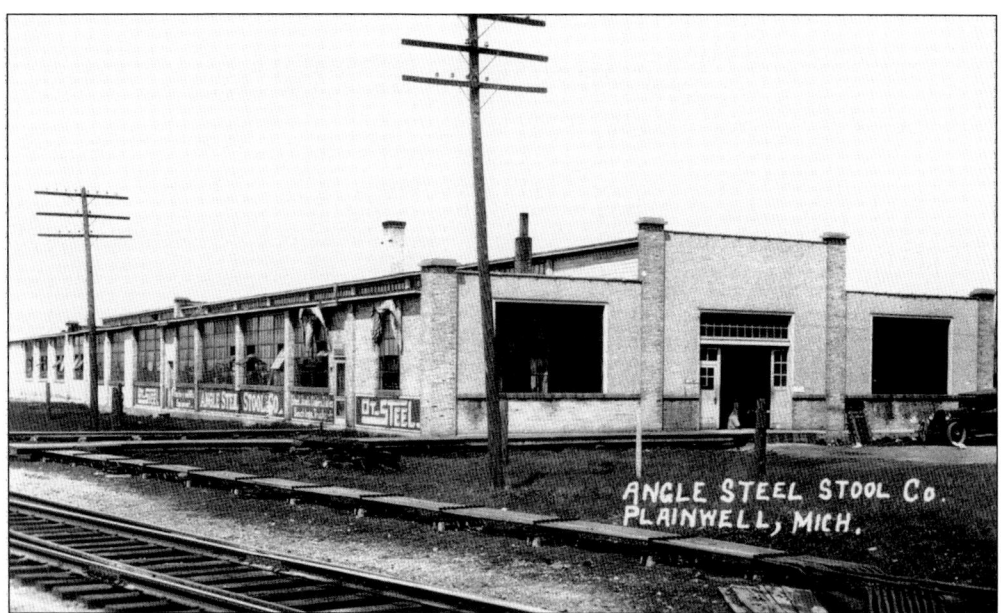

ANGLE STEEL. The Angle Steel Stool Company was established in 1910 by Charles Pipp and John Linsey. Originally located in Otsego, Charles decided to move his business to Acorn Street in Plainwell in 1922. After her husband Charles's death in 1937, Anna Pipp became president of the company. Anna Pipp, a powerful lady, was very active in many clubs and movements including the suffrage movement.

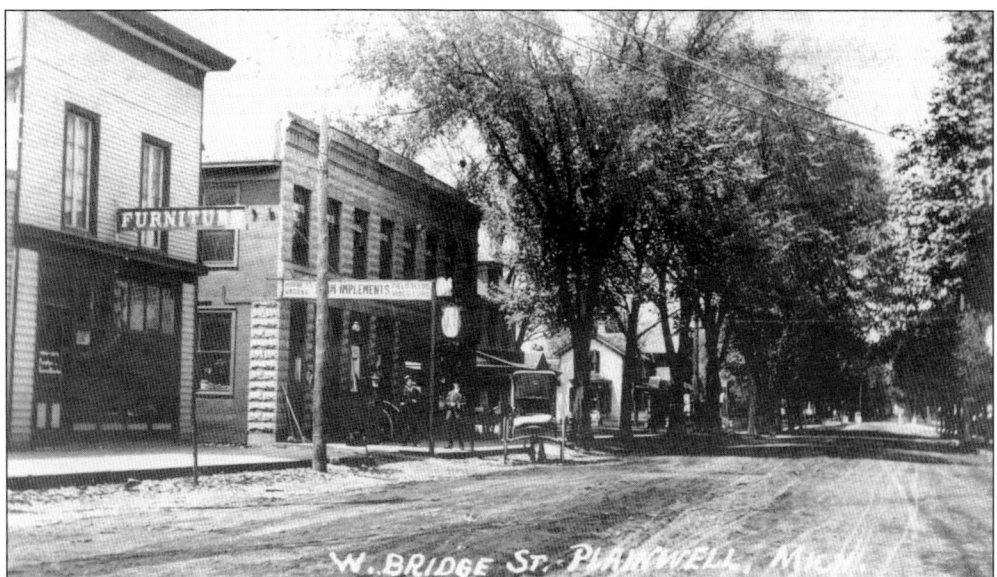

INGRAHAM AND TRAVIS. As stated previously, the Ingraham and Travis building was originally located on the flat iron. In 1903, John F. Eesley traded his land to Ingraham and Travis. A new brick building was then built on the former Eesley property with the grand opening on March 25, 1904. A. H. Warnement, business owner, purchased this implement company in 1936. Warnements is the oldest family-owned business in Plainwell.

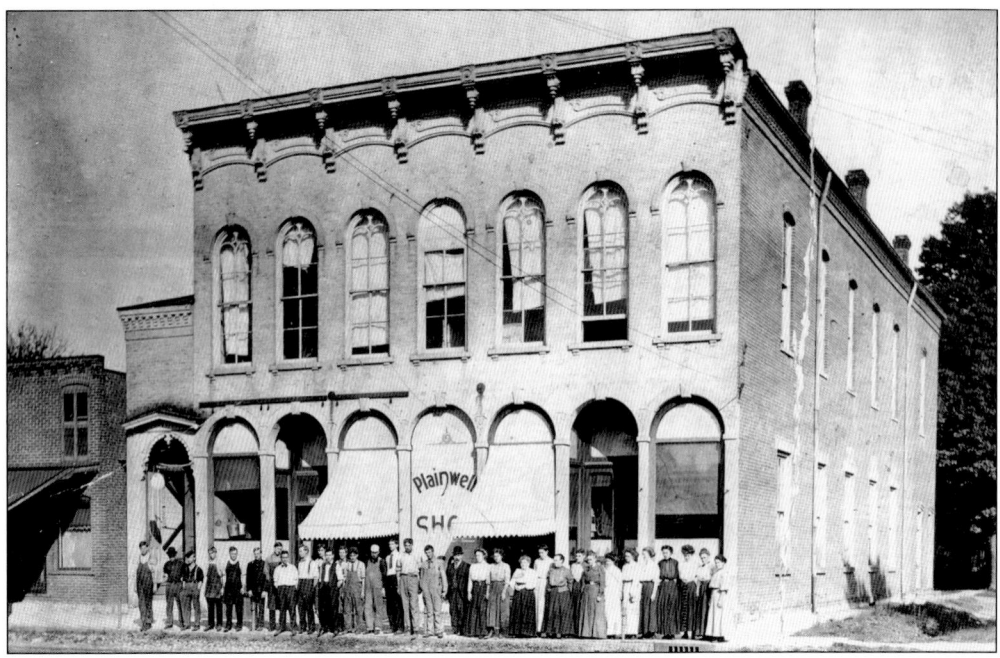

PLAINWELL SHOE COMPANY. John Crispe, a local entrepreneur, converted the Eureka Opera House into the Plainwell Shoe Company in 1906. The Eady Shoe Company of Otsego held stock in the company and helped supply machinery for the factory. However, the business was short lived, and by 1910 the building and all of its assets had been sold. (Courtesy of the Ransom Library.)

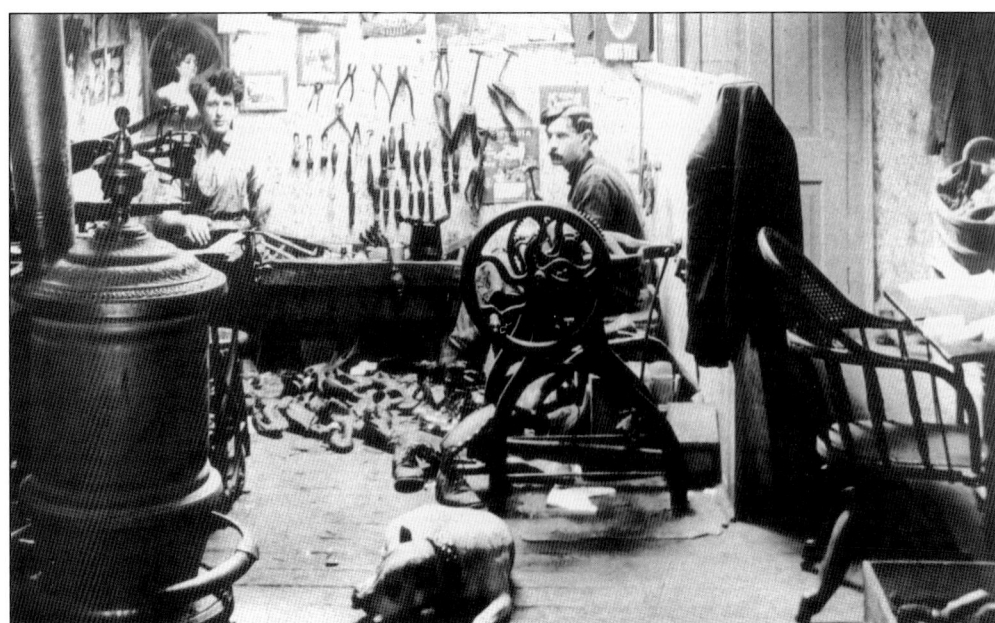

SHOE COMPANY INTERIOR. Here is an inside view of the Plainwell Shoe Company. Views such as this are rare because very few interiors were photographed at that time. Notice the tools hanging on the wall, the shoes on the floor, the sewing machines, and even a dog sleeping on the floor. This company produced mostly shoes for ladies and children.

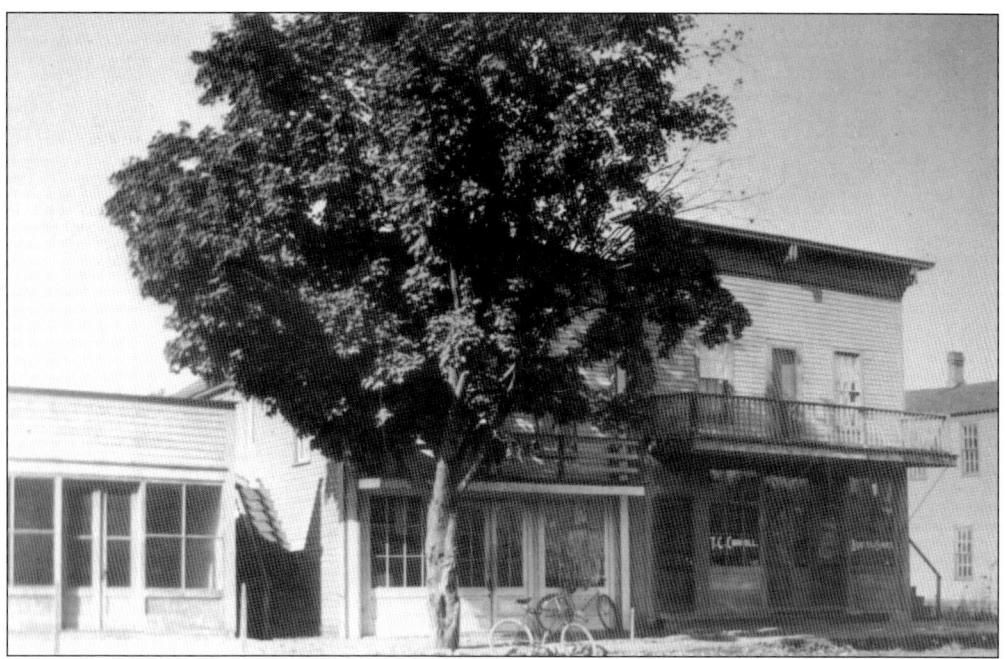

PLAINWELL ENTERPRISE. In 1897, the Plainwell Enterprise was located on the west side of North Main Street, as pictured (center) in this photograph. J. S. Madden and L. C. Wilson founded the newspaper on February 10, 1886. Wilson retired from the business in July 1886, and by January of the following year, Wilson sold his interest in the newspaper to John Henry Madden, John Sargeant Madden's father.

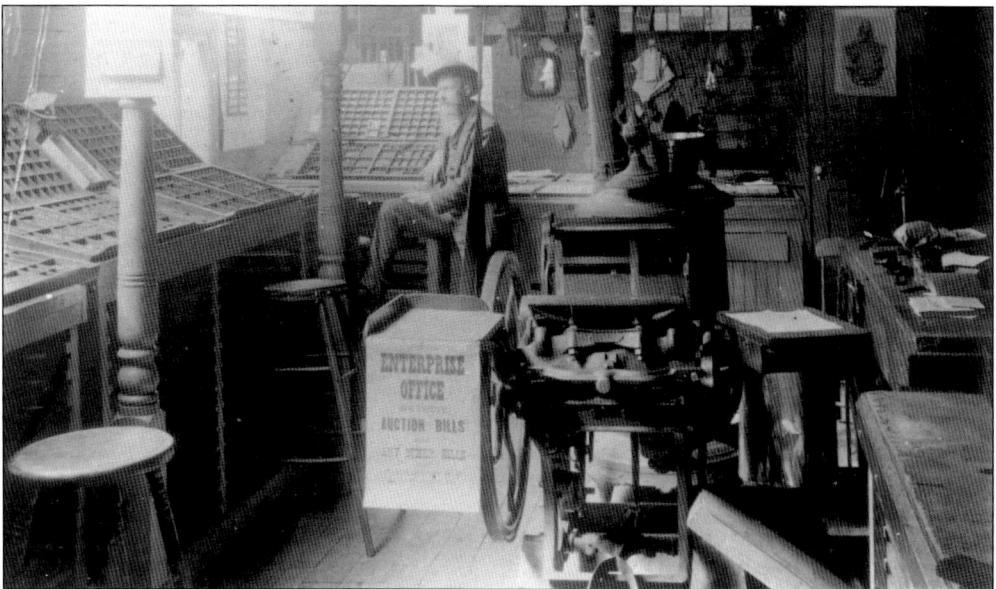

ENTERPRISE OFFICE INTERIOR. John Henry Madden sits by the printing blocks in the print shop and office of the Plainwell Enterprise. Most of the Madden family, at one time, worked for the enterprise. Some of the Madden boys owned or became editors of other newspapers throughout the country. The Madden family owned the Plainwell Enterprise until 1910 when the senior partner John Henry died.

BRIGHAM PHOTOGRAPHY. The first building on the left was built in the late 1880s. J. M. Brigham had his photography studio on the top floor of the building using a skylight in the roof for lighting. Lulu Hitchcock, an apprentice under Brigham, leased the business from 1906 to 1923. Over the years, a number of different businesses have been located in this building. Today Cornell and Associates, realtors, occupy this space.

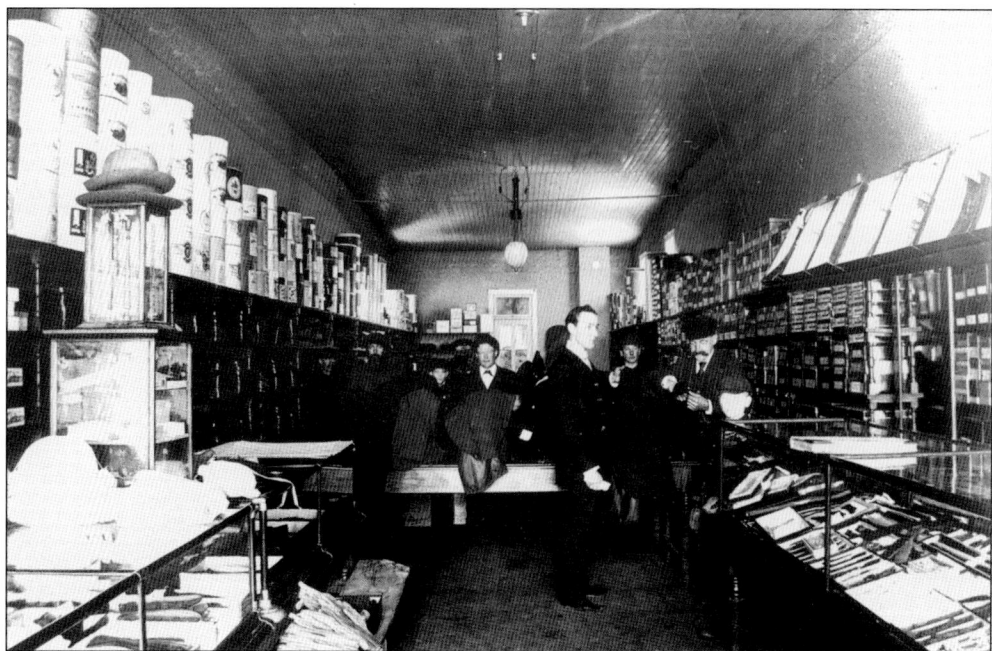

BALDEN AND HITCHCOCK STORE. This shows the interior of the Balden and Hitchcock Clothing Store taken in 1897. The clothing store was located on the south side of East Bridge Street, the second storefront from Main Street. Citizens pictured here are John Hitchcock to the left in the derby hat, Joe Balden center front, and Dr. Stuck examining the coat.

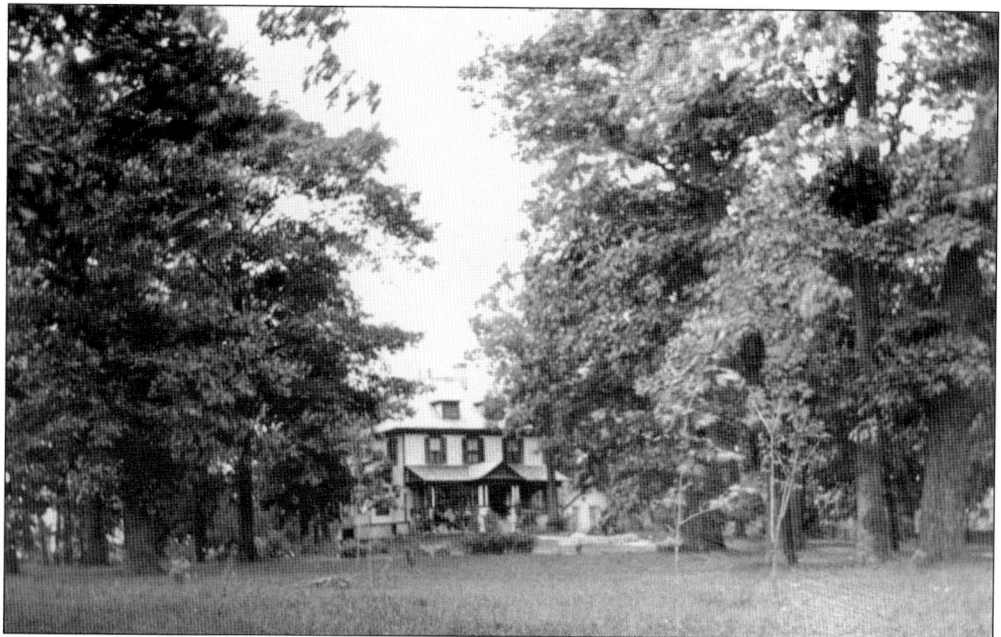

THE OAKS. Originally a private residence, this home was moved in 1865 from River Street (Riverview Drive) to North Main Street. The moving took place during the winter, which turned out to be a bad idea since the home got mired in the mud and snow. The house spent most of the winter stuck in the road. After serving as the Botsford's home, it was sold to James White in 1920.

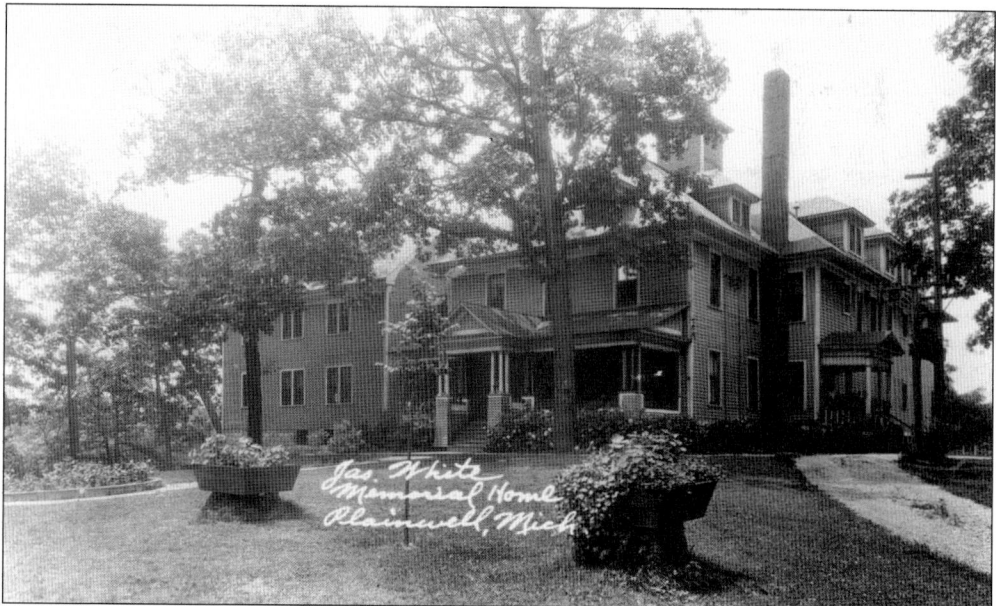

JAMES WHITE MEMORIAL HOME. James White built a large addition on to the house and turned it into a Seventh Day Adventist Memorial Home for convalescing aging patients. It then became Del Vista Sanitarium, Plainwell Sanitarium, Plainwell Residential Care Facility, and Powell's Adult Foster Care Home. Presently it is called the Oaks Adult Foster Care. With each new owner, the home has increased in size.

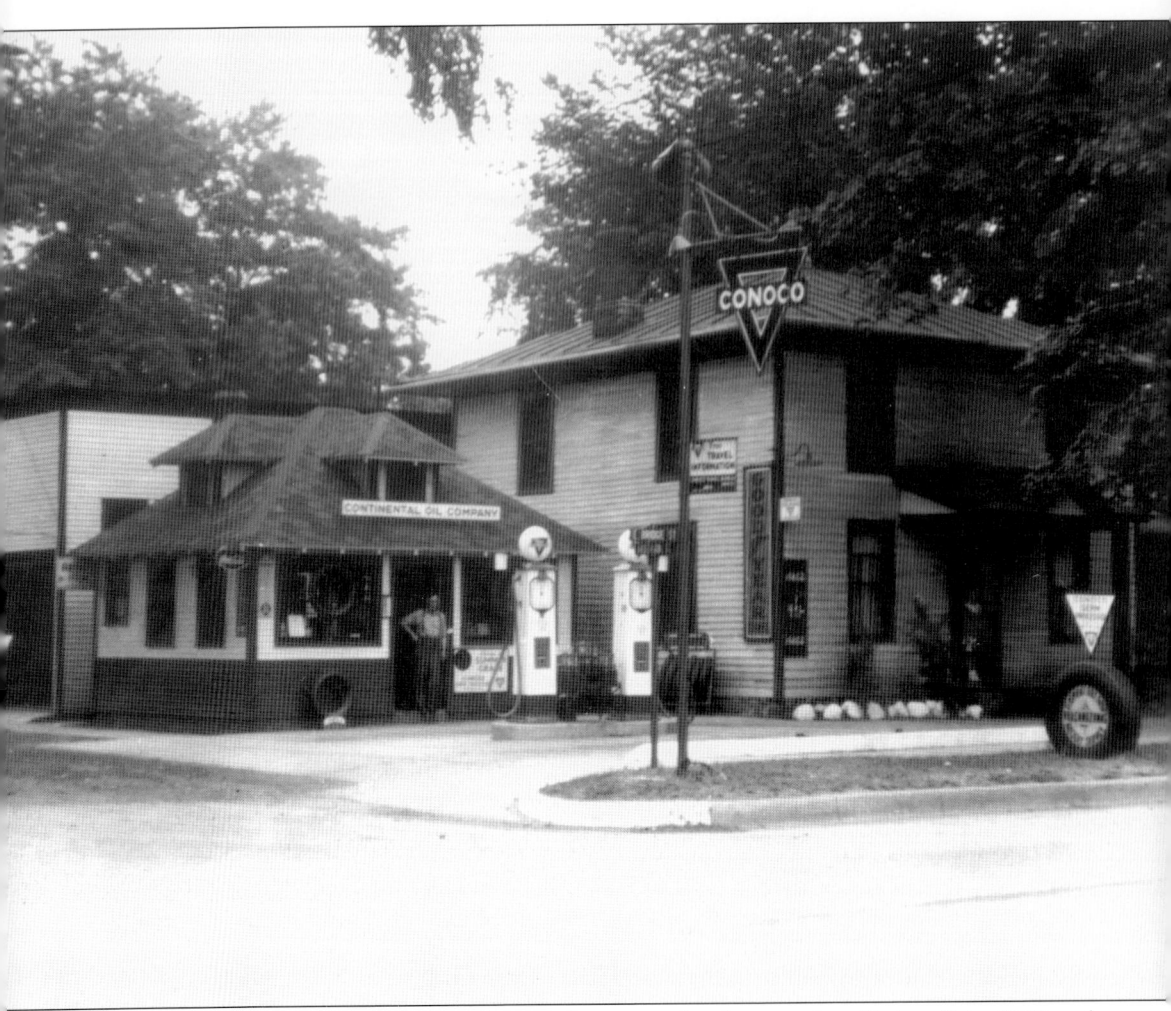

ECREMENT'S GAS STATION. The Clarence Ecrement family moved to Plainwell in 1927 and started a tire business. One year later, they moved to 203 East Bridge Street. Ecrement turned the large garage on the property into a tire and battery shop. A small Conoco Gas Station was built in front of the existing garage in 1930. With the completion of this station, Plainwell had 16 gas stations within the village limits.

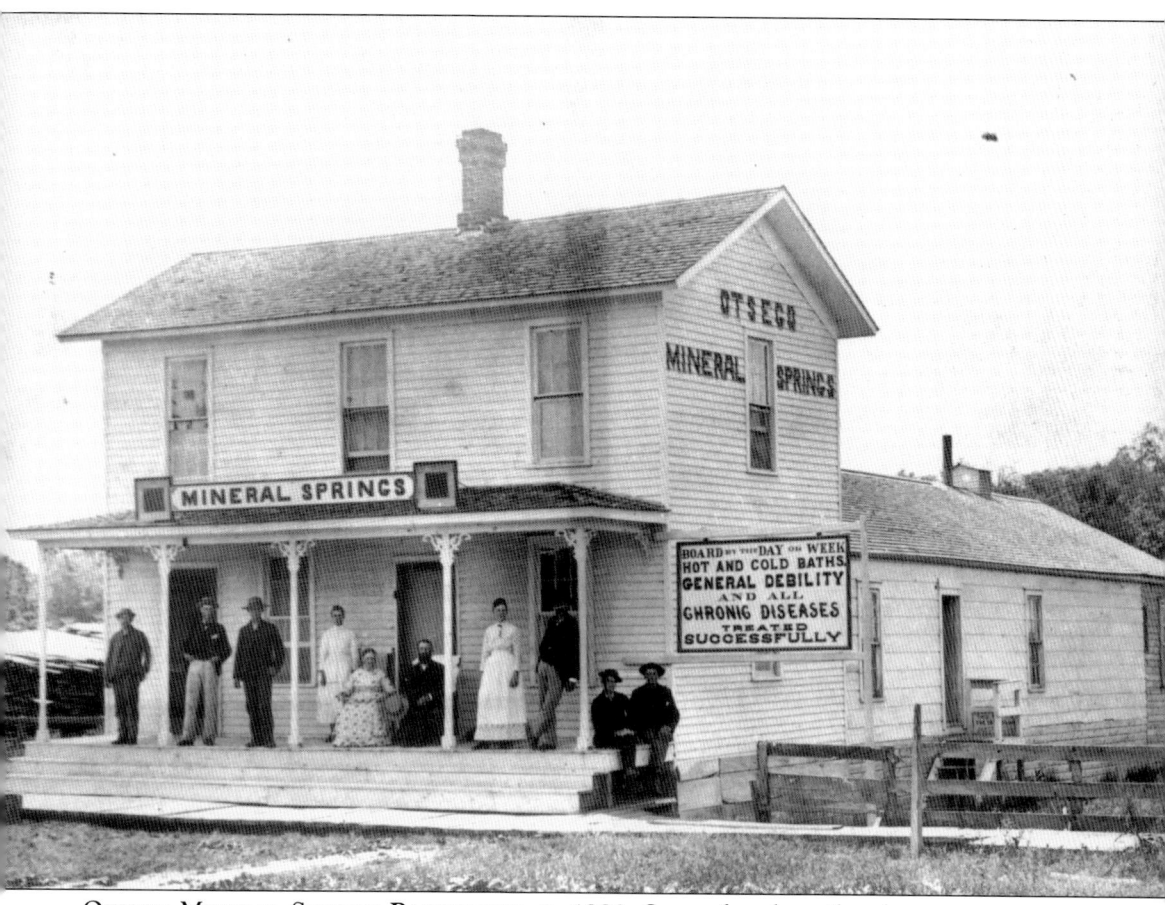

OTSEGO MINERAL SPRINGS BATHHOUSE, C. 1880. Soon after the railroad came to town in 1869, several local businessmen took advantage of Otsego's bubbling springs and quickly built a bathhouse and hotel for tourists who visited them. The enterprise went out of business in the late 1880s due to the local water table being drastically lowered by the new Bardeen Paper Mill across Farmer Street. (Courtesy of the Otsego District Library.)

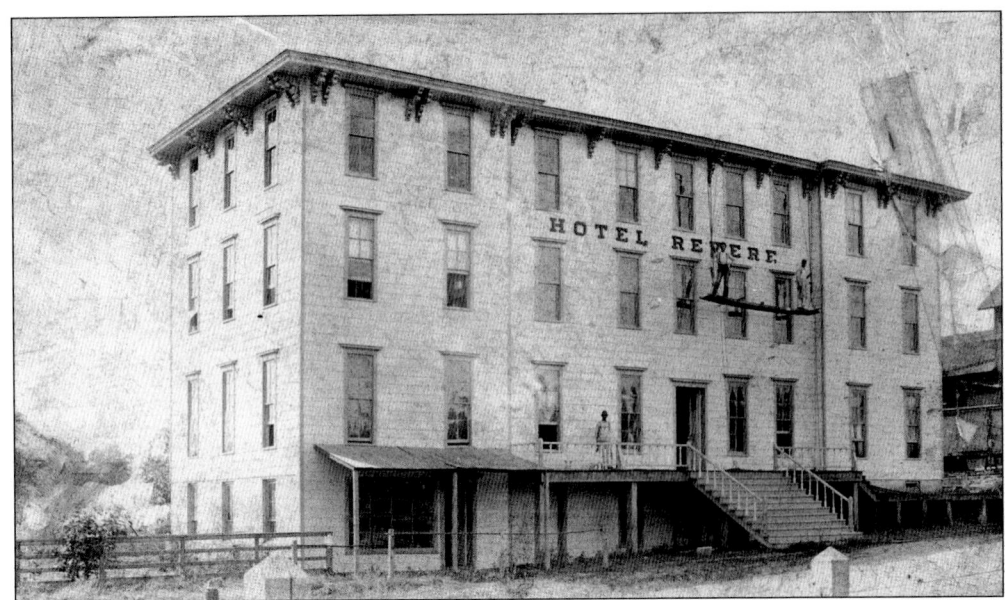

HOTEL REVERE, C. 1885. Located north of the Otsego Mineral Springs Bathhouse near the southwest corner of River and Farmer Streets, the Hotel Revere was built to accommodate visitors to the mineral springs. The three-story building had 30 bedrooms, a ballroom, and kitchen facilities. It was originally called the Mineral Springs House. (Courtesy of the Otsego District Library.)

HOTEL REVERE, C. 1900. In the early 1900s, the Hotel Revere began operating as a boardinghouse and offered rooms for $1 per day and meals for 25¢. Its top floor was later removed, and for years the building was used as a lumber warehouse. The old hotel was torn down in the 1970s. (Courtesy of the Otsego District Library.)

OTSEGO CHAIR COMPANY, 1880. A. B. Stuart started manufacturing furniture in 1871 near the Kalamazoo River on North Farmer Street. By 1880, nearly 100 men and women worked at the factory, making hundreds of furniture pieces every day. The factory had several buildings and storage facilities, including these buildings, which were located where the former Menasha paper plant is today. (Courtesy of the Otsego District Library.)

OTSEGO CHAIR COMPANY, C. 1905. Looking south across Island Park in the late 1800s and early 1900s, one would see the chair company's large wood shop. It was situated on a thin strip of land in between the south millrace and the Kalamazoo River, approximately where the Otsego Public Works building is today. The factory survived in Otsego until 1922. (Courtesy of the Otsego District Library.)

NORTH FARMER STREET, C. 1898. Bardeen Paper Mill No. 2 is on the left, and the dark building on the right at one time was the Otsego Hoe Factory (1875–1883). H. D. Mills received patents for farm implements, and soon after opening his factory, business was booming. An 1877 article reported the company had recently sold 600 dozen hoes and rakes to stores out west. (Courtesy of the Otsego District Library.)

D. M. HALL FURNITURE, C. 1880. Daniel M. Hall was an early settler to Otsego, having arrived in the 1840s. He manufactured furniture and sold it at this store on the south side of East Allegan Street. He was an entrepreneur with many talents. His 1884 business letterhead referred to him as a "Funeral director, furnisher, and practical embalmer." The Hall building burned down in 1900. (Courtesy of the Otsego District Library.)

Marcia Hall Store, c. 1910. Born in 1854, Marcia Hall started her career as an Otsego schoolteacher in the 1870s, and then later opened a shoe store in the 1890s. She also served on the school board and helped organize the Mutual Improvement Club. Her father, Daniel M. Hall, was an early Otsego settler and cabinetmaker. Their 1850s-era family home is used today as the Winkel Funeral Home. (Courtesy of the Otsego District Library.)

Woodbeck Drugs, c. 1907. J. D. Woodbeck operated his drugstore in downtown Otsego from the 1890s to the second decade of the 20th century. Located in the Edsell Building on the southeast corner of Allegan and Farmer Streets, he was known as the "Opera House Pharmacist" because of his close proximity to Otsego's opera house. Also located near him were the DeLano and Clapp Bank and the M. H. Pierce Grocery Store. (Courtesy of the Otsego District Library.)

EADY SHOE COMPANY, C. 1910. In 1903, E. W. Eady began operating his shoe factory on Helen Avenue in Otsego. A second plant was added in 1910, and by 1915 over 150 men and women worked there. Eady also had operations in Plainwell, Hopkins, and South Haven. The factory prospered for many years, but it later faced difficulties caused by the Depression and closed down in 1935. (Courtesy of the Otsego District Library.)

W. C. DANN MILL, C. 1920. William C. Dann built his feed mill on North Farmer Street in 1909. His advertisements in the *Otsego Union* boasted of fine products including his Belle of Otsego Flour and Liberty Pancake Mix. Dann's business lasted well into the 1920s, and it was eventually sold to Clarence and Vern Pike. (Courtesy of the Otsego District Library.)

OTSEGO SANITARY MILK PRODUCTS, 1952. Originally known as the Otsego Creamery, this company began business in 1902. Production skyrocketed, and by 1925 a new facility was built on North Street. During its heyday, the plant would receive 120,000 pounds of milk daily, with half sent out as butter and the other half as sweet cream. Twenty delivery trucks took the company's products throughout Michigan and the Midwest. (Courtesy of the Otsego District Library.)

SHEARS DAIRY, C. 1915. A. I. Shears sold milk by horse and wagon in the 1890s. He later built a milk house and sales room behind his home on Farmer Street. He produced his own ice and later offered ice cream and handmade ice-cream sandwiches. Shears's dairy was sold in the 1950s to Holland's Dairy, and the former site of his plant is now occupied by the Harding's Market parking lot. (Courtesy of the Otsego Area Historical Society.)

MICHIGAN COTTAGE CHEESE COMPANY. German immigrant Max Loebel moved to Otsego in 1926 with the intention of opening a successful cottage cheese plant. Through hard work and determination his company survived the Depression and went on to become a familiar grocery store brand. Pictured here is Russ Grinnel, who drove a semi-truck to the company's plant in Reed City and back every day. (Courtesy of the Loebel family.)

THE NIFTY LUNCH, C. 1935. Lou Severy's first business in Otsego was the Severy Haberdashery. He later operated the Nifty Lunch, a popular eatery, in the 1930s through 1950s. One could eat lunch for 35¢ at the little restaurant on the southeast corner of Allegan and Farmer Streets. (Courtesy of the Otsego District Library.)

FARNSWORTH CHEVROLET, 1952. Mart Schaffer and car salesman Max Tooher stand in front of Mart's truck and his load of wood in this image taken on Kalamazoo Street. The Farnsworth building was constructed in 1930 by Healey and Healey and served as a dealership until 1963 when it was torn down to allow for more parking at Harding's. Farnsworth, then relocated to a new location next to U.S. 131. (Courtesy of the Bronson family.)

LINDSEY'S MOBIL SERVICE, C. 1950. Ready for service, from left to right, are gas station attendants William Pierce, Jim Guidebeck, and Tom Lindsey. This station was located on the southwest corner of West Allegan and Kalamazoo Streets, where the Church of God has a parking lot today. Also occupying its space at one time or another was Bill's Service, Champion's Service, and Big Bill's Restaurant. (Courtesy of the Otsego Area Historical Society.)

HARDING'S MARKET, C. 1963. Mel Harding opened this Otsego grocery in July 1950. Its first parking lot was the site of the bowling alley, which had burned just months before. The local paper reported that the store would be superior to any in the area, even the big supermarkets of Kalamazoo. Roscoe Hill of the Plainwell Harding's helped organize the new store, and Dave Kauffman was its first manager. (Courtesy of Harding's.)

A&P GROCERY, 1956. Otsego's first A&P grocery store came to town in 1928 and lasted only a few years. It returned in the 1940s and eventually found a home on the north side of East Allegan Street. Hinkle's Bakery can now be found in the old A&P building. (Courtesy of the Otsego District Library.)

Three

TRANSPORTATION

OTSEGO PASSENGER TRAIN STATION, C. 1900. The Lake Shore and Michigan Southern Railroad came to Otsego in 1869, offering travelers the speedy convenience of rail service. This photograph shows Otsego's second station, built in 1887 and located on East River Street. G. R. Doxey owned a livery shop downtown and probably was at the station to pick up a customer in his carriage. (Courtesy of the Goodsell family.)

OTSEGO TRAIN STATION, C. 1910. The train made several stops a day in Otsego. The men in this image are patiently waiting for the next train to roll in. Compare this image with the earlier shot and notice the change in chimneys and the absence of the gas lamp fixture on the front of the station. Otsego's last regular passenger train service occurred in 1937. (Courtesy of the Goodsell family.)

THE MILLER FAMILY, C. 1896. Henry and Mabel Miller and son Paul pose for a snapshot atop their 1890s transportation in front of their home on the corner of East Orleans and Fair Streets. Today's city hall building now occupies the site. Paul later tragically drowned in the Kalamazoo River at the age of 16 in 1904. (Courtesy of the Goodsell family.)

AT 207 EAST ALLEGAN STREET, C. 1902. This couple and their 1900-era automobile were stopped at the corner of Allegan and Fair Streets in front of the Daniel M. Hall House, known commonly today as the Winkel Funeral Home. (Courtesy of Winkel Funeral Home.)

A 1909 RAMBLER. These gentlemen and their 1909 Jeffries Rambler posed for a photographer in front of the Union Block on the south side of West Allegan Street. Today they would be parked in front of Otsego Health and Fitness. Notice the convenient spot for the spare tire. (Courtesy of the Otsego District Library.)

PRESIDENTIAL CAMPAIGN STOP, 1900. William Jennings Bryan, the "Silver-Tongued Orator" and three-time presidential candidate, made a whistle-stop visit to Otsego on October 10, 1900. After Bryan's speech, local resident Leland Barney presented him with an $8 Dunlap hat and asked him to wear it on Inauguration Day 1901. This scene was photographed near the northwest corner of Farmer and River Streets. (Courtesy of the Otsego District Library.)

GRAIN THRESHER, C. 1915. William C. Dann with his early 1900s threshing machine and Port Huron steam engine tractor was probably a sight to behold as he rumbled loudly down North Farmer Street to his feed mill. It was once common to see farmers and their haul of grain lined up all along North Farmer Street to visit the gristmills near the river. (Courtesy of the Otsego District Library.)

KALAMAZOO RIVER AT PINE CREEK, C. 1910. The river gave settlers the ability to travel and conduct commerce to and from points along its way. However, between Kalamazoo and Otsego the river was barely navigable, limiting its commercial effect and ruining the development plans of Otsego founding father Horace Comstock. This scene shows the bridge near Jefferson Road that allowed people to cross the river en route to Allegan. (Courtesy of the Otsego District Library.)

FARMER STREET BRIDGE, 1903. Otsego's first bridge was built over the Kalamazoo River at the North Farmer Street location in 1836, financed by Horace Comstock. The bridge pictured above was completed in the 1880s. The buildings to the right of the bridge were part of the Bardeen Paper Mill. Near the tree on the right is the footbridge entrance that led to Island Park. (Courtesy of the Otsego District Library.)

FARMER STREET BRIDGE, 1938. Work on a new bridge had begun in this view looking north on Farmer Street. This was a Depression-era Works Progress Administration project that helped build Otsego's first new bridge at that location since the 1880s. Notice the bales of straw waiting to be used in the papermaking process at the Otsego Falls Paper Mill. For years this company was commonly called the "Straw Mill." (Courtesy of the Otsego District Library.)

FARMER STREET BRIDGE, C. 1940. Here the recently completed bridge with its new sidewalks and guardrails offers a safe crossing for automobiles and pedestrians. Shown here are actually two bridges: one crossing the old millrace and one spanning the river. The structure on the right is the 1907 waterworks building, now renovated and used today as the Otsego Area Historical Museum. (Courtesy of the Otsego District Library.)

NORTH STREET BRIDGE, 1910. In order to accommodate the foot and vehicle traffic that accompanied the new paper mills on the northwest side of Otsego, a bridge was built over the river on North Street. A local newspaper editor in 1907 praised the usefulness of the bridge and dared anyone to complain against it. (Courtesy of the Otsego District Library.)

OTSEGO'S BUS SERVICE, C. 1922. G. Otto Lewis started one of the first bus lines in the state when he began the Lewis Rapid Transit in 1921. The first route went from Otsego to Kalamazoo, but later ones were added to Plainwell, Allegan, South Haven, and Three Rivers. Lewis regularly added newer and larger buses, and his business grew significantly. He sold the business and retired in the mid-1940s. (Courtesy of the Otsego District Library.)

PLAINWELL STAGECOACH STOP. The image seen here is a reprint of an old photograph taken in 1865. While traveling on the Plank Road Highway, the stagecoach stopped at the Plainwell House to rest and get fresh horses on its way from Grand Rapids to Kalamazoo. Only one of these early Michigan stagecoaches has survived. It can be seen at the Michigan Historical Museum in Lansing.

LAKE SHORE AND MICHIGAN SOUTHERN DEPOT. Railroads played an important part in the early development of Plainwell. The Lake Shore and Michigan Southern Depot was Plainwell's first of three railroad stations. Located on the south side of East Bridge Street, it was built in 1868. In later years, the building was used by the Plainwell Elevator as a garden center. The structure burned to the ground on June 25, 1987.

GRAND RAPIDS AND INDIANA DEPOT. Built in 1870, the first wooden station for this company burned on April 28, 1904. Shortly thereafter, a new stucco structure was erected. The depot stood behind the Plainwell Elevator Company facing Acorn Street. Consolidated Rail Corporation (Conrail) eventually took over the operation of the depot. Conrail had the building demolished in the early 1980s.

MICHIGAN RAILWAY INTERURBAN DEPOT. In the spring of 1915, Plainwell's third railroad station, the Interurban, was built behind the Grand Rapids and Indiana depot. It was run by electric power on a third-rail system. Advantages of the Interurban were that it was modern and faster, ran cleaner, made short runs, serviced rural areas, and would stop anywhere. By 1929, all service from the Interurban was discontinued.

INTERURBAN BRIDGE. This photograph shows the construction of the bridge over the Gun River, north of the village, for the Interurban third rail track. It was located three miles north of Plainwell between Ninth and Tenth Streets. Boaz Camfield's steam engine was used to generate the power needed for building the bridge. (Courtesy of the Ransom Library.)

UNLOADING EQUIPMENT. Many activities went on at Plainwell depots. Here a tractor and a threshing machine are being unloaded from a flatbed train car. During this time frame, 1868 to 1929, shipping by rail was the only way possible for the local population to get their merchandise. Consequently, the railroad yards were kept busy at all times.

WORLD WAR I SOLDIERS DEPARTURE, 1917. Many citizens are at the train station to give Plainwell's enlisted boys a big send-off. Standing in front of the Interurban depot are five young gentlemen waiting for the train. The soldiers are, from left to right, Walter Burroughs, Ray Workman, Leslie East, Leland Chapman, and Jack Bellingham. The Plainwell Military Band is waiting to play a patriotic selection.

OTSEGO PLAINWELL MUNICIPAL AIRPORT. Quonset hut hangers, as pictured here, were popular during the 1940s. A 91-acre site was chosen for a new airport after the existing airport on Michigan Highway 89 was unavailable for purchase. The new combined airport was located 1.5 miles north of Plainwell and 2.5 miles east of Otsego. Otsego sold its share of the airport to Plainwell in February 1994.

AFTERNOON DRIVE. This family is out for a Sunday drive in their automobile. Notice the Plainwell banner flying from the back of the car. Automobiles did not start appearing in Plainwell until around 1907. During Plainwell's first homecoming in August 1907, Carrie Soule was seen escorting Michigan's governor Fred Warner around the village in her new motorcar after she picked him up at the train station.

AUTOMOBILE CROSSOVER, C. 1916. Main Street in Plainwell shows the transition from horse-and-buggy vehicles to automobiles. Horse-drawn carriages, service wagons, delivery wagons, and motorized automobiles all appear along the main section of town. Dirt roads were the norm for this period of time even though cement sidewalks had been in existence for over 10 years.

BELLINGER'S HOME AND AUTOMOBILE, 1919. Parked in front of the Bellinger home on Hicks Street is Hal Leslie Bellinger's new car. Bellinger owned the Overland Auto Sales Company and was an experienced driver competing in many automobile races and hill climbs. Ironically even with all of his training and expertise, Bellinger was killed in an automobile accident on his way home from Pine Lake in August 1919.

Four
SCHOOL AND CHURCH

WHITE SCHOOL. The White School, Plainwell's second school, was located west of the original old red schoolhouse at the west end of the flat iron, Hicks Park. It was built in 1855. By 1910, even with the addition of a second story and a small adjacent building, the students had outgrown the facility. The pupils moved to other buildings while a new brick school was being built.

BRIDGE STREET SCHOOL. Plainwell voters agreed to fund a new brick structure on the White School property in 1910. The main wooden school building was then moved to Jersey Street. Bridge Street School was to be completed and usable by September of that same year, but because a kindergarten was added to the original floor plan, the school was not opened until 1912. By 1968, elementary classes were discontinued here.

SCHOOL ADMINISTRATION BUILDING. The school administration offices took over the Bridge Street building in 1968. The edifice was used for this purpose until 1984 when the offices moved to their new headquarters on Starr Road. Shortly thereafter, the Bridge Street building was sold to a private individual. Today it is an apartment complex.

ELEMENTARY SCHOOL. Groundbreaking for the elementary school on Gilkey Field occurred in January 1950. By December 1951, students were attending school in this new building. The school board purchased land simultaneously for two additional elementary schools in 1955. In January 1957, Starr and Cooper Elementary schools opened. With the completion of the two new elementary schools, the name of the original elementary school was changed to Gilkey Elementary.

UNION SCHOOL. As the community grew, the school board saw a need for a high school. An allotment was set aside for the property and material to complete this project. The new two-story building known as the Union School opened in 1870. In 1873, the school graduated five students. Demolition of this building occurred in 1920, making room for a larger more modern high school. (Courtesy of the Ransom Library.)

BUILDING THE HIGH SCHOOL. In 1920, the citizens of the village voted to fund a new high school. The Union High School had to be torn down so that the new high school could be erected on the same land. Students were displaced for two years and had to meet in various places throughout the village. Here the sub-floor is being placed on the new school. (Courtesy of the Ransom Library.)

HIGH SCHOOL, 1920. After 50 years of service, the Union School was replaced. A new high school was built at the cost of $175,000. Over the years this building not only served as a high school, but it housed grades 4 through 12. During the 1970s, it served as a junior high school. The building was destroyed in 1975 after the present middle school was erected.

FOOTBALL TEAM, 1897. Few high school football teams existed in the late 1890s. This local high school team had a successful football season with a record of five wins, one loss, and one tie game in 1897. Two years later, many of these same football players went on to play in a championship game on Thanksgiving Day between Plainwell and Pontiac. Pontiac won by one point.

BASKETBALL TEAM. In 1928, Coach Fleming's team after winning the district and the regional tournaments went on to participate in the state finals. These players were Plainwell's first team to reach a state competition. The players are, from left to right, (first row) John Dean, Bob Howard, Rollin Earle, Ralph Quigg, and Delbert Smith; (second row) Frank Adams, Jack Hansen, principal Ben Bulkema, coach Fleming, Abe Brenner, Howard Sibbersen.

HOME ECONOMICS CLASS, 1953–1954. Illustrated here are four girls from the Plainwell High School home economics junior class planning for their future homes. The houses, built to scale, are patterned to accommodate a 1954 family with an average income. Participants seated are, from left to right, Sharyn Kaechele, Carol Hutchinson, Donna Earle, and Charlene DeKam. (Courtesy of the Ransom Library.)

SENIOR CLASS PLAY, 1937. "The Patsy," a play given in January 1937 by the Plainwell High School senior class, was reported as being a pleasure to watch. Performing in this play were, from left to right, (seated) Phillip Link, Alice Kools, May Sibbersen, John Stamp, Geneva Johnson, Gene Parker, and Arlene Hardy; (standing) assistant director Kathryn Outwater, Floyd Parmelee, director Kent, and Earl Nelson. (Courtesy of the Ransom Library.)

64

SENIOR TRIP, APRIL 1930. For many years Plainwell's graduating seniors went to Washington, D.C., for their senior trip. Gathered in front of Mount Vernon is the senior class from 1930. Notice that superintendent M. L. Fear appears on both ends of the top row. It must be magic, or maybe a panoramic camera.

QUEEN CONTEST. A contest to elect a Plainwell queen was conducted on September 10, 1953, in Plainwell. The gowns for the contestants were donated by the local merchants. After all of the votes were counted, Linda Brundage was crowned queen. The queen and her court as they appeared are, from left to right, Riva Mills, Shirley Waldron, Donna Anson, queen Linda Brundage, Charlene Angeletti, Joanne Khodl, and Carol Sue Hutchinson.

MAY DAY FESTIVAL. This early spring festival was a celebration of fertility. A traditional May Day celebration in the early part of the 20th century was when participants engaged in intricate dances and wove streamers around a pole decorated with spring flowers. This image shows just such a dance performed by fifth-grade students from Bridge Street School in 1916.

MAY DAY CELEBRATION. The year 1915 finds these students celebrating the festival in an entirely different way. Circling the village, pupils from Bridge Street School have dressed up for a May Day parade. Seated on the float are royalty king Ronald Zimmerman and queen Eleanor Onontiyoh. No identification is available for the remaining students. (Courtesy of the Ransom Library.)

RECESS TIME, 1940. Recess time finds the students on the playground at Bridge Street School having lots of fun on the merry-go-round. Evelyn Yerden's 1940 class had a choice between swings, slides, teeter-totters, climbing bars, and the merry-go-round. Some of this playground equipment is no longer considered safe for present-day use.

SCHOOL CLASS, 1939. Members of the class are, from left to right, (first row) Bethel Higgs, Pat Sonnerville, Nydia Nichols, Shirley Nichols, Majorie Town, Mary Town, Bette Astle, Treva Predum, and June Howard; (second row) Jim Cobb, Edward Motter, Jack Stenberg, Charlene Buxton, Mary-Ellen Murray, Mary Harmon, Marcia Madison, Donald Simpson, Jim Beldon, and Jack Engles; (third row) Jim Ellinger, Robert Howard, John Baker, Roy Shively, teacher Maida Beckner, John Angeletti, Jerry Meredith, Albert Warnement, and Nolan Payne.

BOY SCOUT TROOP. Plainwell organized its first Boy Scout troop in 1918. Assembled here are, from left to right, (first row) Robert Brownell, Robert Zimmerman, Earl New, Eugene Hibbard, Elmore Buskirk, and Fred Bliss; (second row) Leslie Bellingham, Arthur Sisson, Warren Bellinger, Murray Black, leader Stephen Smith, Carlyle Williams, religious counselor Howard Jerrett, Dana Potter, and Delos Evans. (Courtesy of the Ransom Library.)

PATROCLUS A. LATTA, C. 1870. Well-loved by his students, Patroclus Latta was Otsego's principal during the late 1860s. Latta was also an educated lawyer, but teaching was his love. He brought his guitar to class and often held singing classes. His popular style attracted students from throughout the county to his teacher training courses. Latta died in Saugatuck in 1911. (Courtesy of the Otsego District Library.)

JAMES BALLOU, C. 1870. Professor James Ballou was a more serious teacher than Latta, but nonetheless was held in high regard by his students and parents. He later became Allegan County's first superintendent of schools in 1867. Latta followed him as the second superintendent in 1869. Ballou also worked at a grain mill in Otsego when he was not teaching. (Courtesy of the Otsego District Library.)

OTSEGO SCHOOLS' FACULTY, 1890. These teachers taught at various schools in Otsego during the late 1900s. From left to right are Julia Stoughton, Mary Chase, Emma Van Wyck, Permelia Monroe, Miss Arnold, Helen Cross, and George Nevins. Stoughton taught in Otsego for 50 years, Van Wyck was the daughter of a Methodist minister; and Monroe taught for 48 years in the rural schoolhouses. (Courtesy of the Otsego District Library.)

WARD SCHOOL, C. 1900. Built in 1892, the Ward School originally provided space for the village's lower grades. It served as a school until 1910, when the three-story Oakwood School was built to house those students. It was later known as the American Legion Hall and was eventually torn down in the late 1960s. The Congregational Church now occupies the site of the school. (Courtesy of the Otsego District Library.)

OTSEGO SCHOOL, 1897. This red brick school was built at a cost of $10,000 in 1897 on the site of today's Allegan Street Elementary. It had six classrooms on the first floor for the grade school and a large high school room that could seat 110 students on the second floor. It met an unfortunate demise in 1902 when it burned down. (Courtesy of the Otsego District Library.)

OTSEGO SCHOOL, C. 1915. Constructed in 1902 to replace the school that had burned earlier that year, this version contained 10 classrooms. Community pride was evident with the new school and the quality of the district's education as local advertisements boasted of electric clocks in the classrooms, a large library, teachers who were trained specialists, and the presence of "open-air courses in physical education." (Courtesy of the Otsego District Library.)

OTSEGO SCHOOL, C. 1925. A large addition to the east side of the school was built in 1923. This image from the left shows that addition, the attached 1902 building, and the 1910 Oakwood Building. The Allegan Street location, since its first school in 1868, has always had a stand of magnificent oak trees. (Courtesy of the Otsego District Library.)

OTSEGO HIGH SCHOOL TRACK TEAM, 1927. The track team in the 1920s achieved success under longtime coach and high school principal Fordyce Bragg. One of the trophies pictured was for winning the 1925 Class C State Championship. Seated in the first row, far left, is Leo Watters, who led the Otsego Boy Scouts and worked as a bus driver for the school district. (Courtesy of the Otsego District Leader.)

SEVENTH-DAY ADVENTIST SCHOOL, 1911. Located on West Hammond Street, the Seventh-Day Adventist church established a school in Otsego in 1909. To the right of the school was the administration building. The school eventually closed in 1911 or 1912. The impressive stucco building later suffered a major fire, however, it still exists and is used today as an apartment building. (Courtesy of the Otsego District Library.)

AT 326 WEST HAMMOND STREET, 1909. The Seventh-Day school was run by the church's West Michigan Conference and intended to receive students and support from the area's 75 churches. After enrolling 60 students and graduating 6 its first year, the school declined in numbers significantly the next year. The administration building was fashioned after the California bungalow style, and today it is used as a home. (Courtesy of the Otsego District Library.)

ADVENTIST BOYS DORMITORY, 1910. Gathered for a portrait on the front porch of their dormitory, these Adventist students attended the short-lived West Michigan Conference School of the Seventh-Day faith. The dormitory is used as a house today, and it can be found on Conference Street on Otsego's west side. Conference Street was named after its early-1900s Adventist influence. (Courtesy of the Otsego District Library.)

OTTO SCHOOL, C. 1935. School District No. 4, or as it was more commonly referred to, "the Otto School," was a schoolhouse built in 1872 on the George Otto property west of Otsego on 102nd Avenue. It was on the north side of the road, right around the bend from Nineteenth Street. It ceased as a school in the 1930s and then held the Pine Creek Sunday School. (Courtesy of the Otsego District Library.)

DIX STREET ELEMENTARY, 1953. To ease the overcrowding caused by a growing school district, Dix Street Elementary was dedicated and opened in 1953. It happened at a convenient time—right after the 1952 school fire that destroyed the Oakwood elementary building. The new school was located on the old Edsell and Lawrence farms. Its first principal was Leon Stone. (Courtesy of the Otsego District Library.)

OTSEGO ELEMENTARY CHOIR, 1956. Directed by Nancy Crawford, this group of musically talented fifth and sixth graders gathered for a portrait in the new Dix Street gymnasium. Concerts back in the 1950s were held at the Dix Street gymnasium or at the stage in the old high school building. The elementary choir still continues to this day as the "Stars" program. (Courtesy of the Otsego District Library.)

BAPTIST CHURCH. In 1864, a total of 22 members from Gun Plain Township joined together and petitioned for a Baptist church. The petition was granted. By 1866 a permanent pastor was installed. Rev. John Fletcher, a former chaplain in the Civil War, agreed to come to Plainwell, serving for more than 50 years. The church, seen in this photograph, was razed in 1965 making room for the present Baptist church.

PRESBYTERIAN CHURCH. A Presbyterian Society was organized in Allegan County in 1836. One year later a similar organization was arranged for the Plainwell area. Their first church was built 2.5 miles north of the Junction. This original church was moved in 1866 to the village. It was used by the Presbyterians until a new church was constructed in 1872. The Catholic church then purchased the early building.

PRESBYTERIAN CHURCH PHOTOGRAPH. Throughout the years, the Presbyterian church has been remodeled numerous times. Shortly after it was built in 1879, an addition was erected. Major remodeling occurred in 1960 when the entire interior of the church was reconstructed. At that time, the main entrance to the church was changed from the front to the side.

METHODIST CHURCH. In 1836, a small group of citizens met at the home of Elisha Tracy in Silver Creek to form the Plainwell Methodist class. Circuit riding preachers came here to preach the gospel. By 1869, the Methodist Church had enough money to break ground for a new building. Dedication for the church took place on February 3, 1870. Many additions have been made to this original church building.

METHODIST CHURCH BELL TOWER. From the beginning the Methodist church bell has called its members to worship. Because of decaying timbers, in 1940 the 1,200-pound bell from the Methodist tower was removed and sold. A new brick bell tower was constructed in 1976. At that time, the Methodist Church purchased an unused 800-pound bell from the Baptist Church to be placed in this new tower.

OTSEGO ADVENTIST CHURCH, C. 1900. The local Adventist congregation can trace their organizational beginnings to the George Leighton home at Pine Creek in 1861. Church founder Ellen White had her famous "Otsego Vision" during a service at the Aaron Hilliard home in 1863. In 1867, the Adventists borrowed $100 from the Allegan church to help pay for the construction of their house of worship on South Farmer Street. (Courtesy of the Otsego District Library.)

BAPTIST CHURCH, C. 1910. The First Baptist Church of Otsego was Allegan County's first organized church when it was established in 1835. They met in homes from Cooper Township to Allegan until 1842 when Otsego became the central location. Their first building was dedicated in 1863 and renovated in 1892. The house on the left was the 1907 parsonage; it was later moved to Fifteenth Street. (Courtesy of the Otsego District Library.)

OTSEGO FIRST BAPTIST DRIVE-IN CHURCH. Drive-in movies became popular in the 1950s, and this local church took advantage of the craze by offering a drive-in Sunday evening service in the summertime. The church began these outdoor services in 1953 at its property next to Brookside Park. Seen here is usher Curtis Holden with an offering plate and a collection of kids atop their family Cadillac. (Courtesy of the First Baptist Church of Otsego.)

CONGREGATIONAL CHURCH, c. 1900. The Congregationalists started meeting in Otsego in 1837. A church was built in 1846 at Farmer and Franklin Streets—at that time the southern edge of town. It burned to the ground in 1865 and was replaced by this one in 1867. Notice the hitching post to the left of the church, and to the right is the 1892 Ward School. (Courtesy of the Otsego District Library.)

CONGREGATIONAL CHURCH, C. 1910. In 1907–1908, the church received a makeover. The 1867 wooden frame structure was moved slightly to the west, a new addition was built to east of the old section, and then the entire exterior was encapsulated with poured cement. It had a full basement for Sunday school, a furnace, and 350 yards of new carpet for the auditorium. (Courtesy of the Otsego District Library.)

REV. GEORGE B. AND ANNA KULP, C. 1890. Rev. Geroge B. Kulp served the Methodist Church in Otsego from 1887 to 1890, at a time when the church experienced great growth. The church's 1889 membership numbered 315 individuals, and it became clear that their 1847 building was in need of replacement. Plans were put into place in early 1889 for a new structure. (Courtesy of the Otsego District Library.)

METHODIST CHURCH, 1889. In this image the Otsego Methodist faithful gather for a photograph during the cornerstone ceremony for their new church. Constructed by local builder William Healey and based on plans by architect Charlie Prentiss, it was dedicated in December of that year. It eventually cost $7,500. The church still stands, and in 2003 it received a State of Michigan Historical Marker. (Courtesy of the Otsego District Library.)

ST. MARGARET'S, C. 1910. Organized in 1887, the Catholics built their church in Otsego in 1890. It was located on the grounds of an old park barely referenced anymore called Riverside Park. The local baseball team played there in the 1880s. The church's first service was Christmas 1890, and it was officially dedicated on September 13, 1891, by Bishop John Foley. (Courtesy of the Otsego District Library.)

ST. MARGARET'S, C. 1940. The church received a generous gift from the Rose Driessen estate in 1937 for a larger building. The new edifice of brick, stone, and ornate details and statues was completed in 1938. The seven-foot marble statue of St. Margaret arrived from Italy in 1940, just before that country declared war on France and England. (Courtesy of the Otsego District Library.)

CHURCH OF GOD, C. 1935. The first services for the Otsego Church of God were held in the opera house in 1921. By 1924, the church had purchased a house on Kalamazoo Street for their worship. Another update to the building occurred in 1949 when it was enlarged and a brick exterior was added. In 1961, a new sanctuary was built, and in 1975, the educational unit was added. (Courtesy of the Church of God.)

Five
PAPER MILLS

BARDEEN PAPER COMPANY ADVERTISEMENT, 1887. Ready for business, the Bardeen Paper Company sent this letter advertising its capabilities to potential customers. It is dated December 27, 1887, which was one day after the mill ran its first paper, and only eight months from the time construction on the plant began. The mill initially employed 200 male and female workers in Otsego. (Courtesy of the Otsego District Library.)

Otsego, Mich., Dec. 27, 1887.

To Whom it May Concern:

We are pleased to announce we are in full running order, and solicit a share of your orders in the line of S. S. and S. C. and Ex. M. F. Papers, made of Rag Stock.

Situated adjacent to L. S. & M. S. Ry. depot, we can ship twice daily each way, loading directly from mill into train and avoiding all delays.

We shall, from time to time, mail you samples of our products, and the numbers stamped on same are office reference numbers only, and if you wish quotations or paper matched, by quoting us the number, we can accommodate you promptly. If there is anything wanted you do not receive samples of, please advise us.

With the compliments of the season, we remain,

Yours very respectfully,

The Bardeen Paper Co.

GEORGE BARDEEN. The father of Otsego's paper mill heritage, George Bardeen received his training from his stepfather and the founder of the Kalamazoo Paper Company, Samuel Gibson. Bardeen would eventually help start seven mills in Otsego. Bardeen was a generous man who participated greatly in Otsego's community affairs. He passed away in 1924 at the age of 73. (Courtesy of the Otsego Area Historical Society.)

BARDEEN PAPER MILL, C. 1910. Located on the north side of the river, the site for the Bardeen mill was chosen by George Bardeen and his financiers in early 1887. It was the only potential site not flooded that spring. This view shows a massive complex that was later home of the Otsego Falls Paper Company, Menasha Corporation, and Otsego Paper. (Courtesy of the Goodsell family.)

BARDEEN MILL EMPLOYEES, C. 1915. Standing next to a huge paper machine at a Bardeen mill, these young men worked 10-hour shifts, six days a week. In the early days of the local mills, boys could forgo high school and enter the mills at age 16. It is unclear why these employees had their pants rolled up and no shoes on their feet. (Courtesy of the Otsego District Library.)

BARDEEN PAPER MILL NO. 2, C. 1920. With paper production booming, George Bardeen's second mill began operating in 1891 on the west side of North Farmer Street. Its massive 110-inch machine made book, lithograph, map, and railroad parchment papers. Together the Bardeen mills produced 35 tons of paper every 24 hours. Bardeen Mill No. 2 survived until the Depression when it closed and was torn down in 1935. (Courtesy of the Otsego District Library.)

BARDEEN PAPER MILL NO. 3, C. 1910. By 1899, George Bardeen had three mills in operation. This small mill was situated in a refurbished 20-year-old lumber mill, and it could produce seven tons of paper per day. In 1917, a great fire destroyed No. 3, and many locals believed it was the work of a German sympathizer. (Courtesy of the Otsego District Library.)

BARDEEN MILL NO. 1 BEATER ROOM, C. 1900. These men had the job of operating the machinery used in beating and refining the pulp that was used to make paper. Rags and waste paper used for the pulp were often delivered by way of train cars right to the mill's receiving door. The beaters were huge steel bowls with powerful and dangerous mixers. (Courtesy of Jackie Andrus.)

BARDEEN MILL NO. 2 SORTING ROOM, C. 1900. Women were often hired to work in the office or to sort the rags and papers used for pulp. Their job was to weed out poor-quality materials and to remove foreign objects that could damage machinery. The newspaper would often report stories of sorters finding valuable objects like cash and jewelry. (Courtesy of Joyce Sheldon.)

MAC SIM BAR PAPER MILL, 1910. Named after its lead financiers, M. B. McClellan, Samuel Simpson, and George Bardeen, the Mac Sim Bar received capital investments in the amount of $120,000 from local residents and business owners. When built in 1906 on Otsego's northwest side, it was the largest paper mill in the country and could produce 260 tons of paper every week. (Courtesy of the Otsego District Library.)

BABCOCK TISSUE MILL, 1915. One year after the Mac Sim Bar was organized, Bardeen set up three smaller mills to be built near the "Mac": the Babcock Tissue Mill, the Coated Paper Company, and the Paraffin Paper Company. The Babcock Mill employed 30 men and was later known as the Wolverine Paper Company. In the 1920s, it was absorbed by the Mac Sim Bar. (Courtesy of the Otsego District Library.)

OTSEGO COATED PAPER COMPANY, C. 1910. Located near the corner of North Street and Helen Avenue, the Coated Paper Company opened in 1907, and by 1910 it had doubled in size due to a growing business. Its purpose was to coat the paper made at other local mills. The factory later merged with Allied Mills of Kalamazoo, and it eventually closed in the 1950s. (Courtesy of the Otsego District Library.)

MAC SIM BAR DELIVERY TRUCK, C. 1948. The Mac Sim Bar's own fleet of trucks would make trips daily throughout Michigan and the Midwest, delivering finished paperboard and then returning to the plant with a load of office paper stock for recycling. By the 1950s the plant would receive about 270 tons of raw material every day from its own vehicles and outside trucks. (Courtesy of Bob Fales.)

OTSEGO FALLS PAPER MILLS' FLEET, C. 1950. Bardeen Mill No. 1 was purchased in 1934 by David H. Greene and became the Otsego Falls Mills. During the 1930s and 1940s it was known commonly as the "Straw Mill," as it used straw in its papermaking process. It later became one of the first mills to use wood pulp in making paper. (Courtesy of Russ Culver.)

Cummings Tour at the Mac Sim Bar Mill, c. 1955. A tradition apparently only in the 1950s was for the different crews at the Mac Sim Bar to occasionally have their group portrait taken. Standing at the far left is superintendent Walter Wolfe and next to him is Jeff Cummings. This group of men operated a shift in the machine room. (Courtesy of Dale Orr.)

PLAINWELL PAPER COMPANY. January 26, 1886, marked the beginning of the Michigan Paper Company when 25 local businessmen incorporated to form this business. Energy from the millrace, built in 1856, provided the power to run the mill. In 1890, the Michigan Paper Company purchased the building of an earlier paper mill, the Lyon and Page Mill, founded in 1872.

PREPARATION FOR BUILDING. The next step in starting the business was to construct buildings and purchase equipment. Clearing the land for the construction of the Michigan Paper Company began immediately after incorporation. Notice the men and horses clearing the land and getting it level so that construction of the building could begin.

OFFICE BUILDING. The Michigan Paper Company office building was completed. The front of the office faced Allegan Street. Ivy covered the exterior. From the beginning, it was the founders' aim to produce a high quality of white paper from waste paper. By 1887, the mill began producing paper at the rate of eight tons of paper per day.

MILL EXPANSION. In 1906, seven new buildings were constructed to accommodate a major increase in production. J. D. Wagner was elected as the company's new president. A second paper machine was also installed that year. The purchase price for the new machine was $23,000. With the additional paper machine, production increased to 15 tons of paper per day.

PRESIDENT GILKEY. Seated at his desk in 1914 is John W. Gilkey, now president of the Michigan Paper Company. Gilkey, at that time, became the principle stockholder in the company. Between 1910 and 1912 two more paper machines were purchased, bringing the capacity of production to 50 tons of paper per day.

PAPER MILL SMOKESTACK. This huge smokestack was built in a period of three weeks by three masons and a laborer for the Michigan Paper Company in 1906. It contained 220,000 bricks. The chimney itself varied in thickness, narrowing at the top with the interior diameter remaining the same from top to bottom.

FREE RIDES. While building this gigantic smokestack, free rides were given to Plainwell citizens to go to the top of this 150-foot chimney. Two people stood in an elevator inside of the smokestack, leaning forward so that they would not bang their heads, and rode to the top. Once on top, they would step out onto a platform to a magnificent view of the area and an unforgettable experience.

RAW MATERIAL. Employees from the Michigan Paper Company are unloading waste paper from freight cars to be used as raw material in the production of the new fine white paper. These freight train cars ran over a spur track made especially for the paper company. It connected with the main railroad track on East Bridge Street.

DEMOLITION OF OFFICE. The Michigan Paper Company office building on Allegan Street was torn down in 1952 to make room for the expansion of the warehouse. A new office was made available in one of the existing buildings. W. C. Hamilton and Sons, later known as Hamilton Paper Company, purchased the company in 1954, ending Michigan Paper Company's 70-year ownership.

AERIAL VIEW. Here is a birds-eye view from the air of the entire paper company in 1947. By this time, a paper-coating process had been introduced. Dwight Stocker was now president of the company. Part of the mill was converted to the production of newsprint for the Booth Newspaper chain.

Six
DISASTERS

THE 1916 FLOOD. The Kalamazoo River and the millrace border the downtown area of Plainwell. Because of this, it has had its share of floods. In the late 1800s and early 1900s, with the onset of spring, bridge washouts and floods from melting snow and water runoffs occurred on a regular basis. Located next to the millrace, West Bridge Street, along with Hicks Park, are under water.

FLOOD OF 1947. Another flood is shown in this image. Five fully-loaded, railroad train freight cars were placed on the trestle bridge to stabilize the bridge and keep it from being washed down the fast-moving Kalamazoo River. Most of the floods that have occurred in recent years have been in the Sherwood Park and North Sherwood Avenue area next to the Kalamazoo River.

HOMES FLOODED. The Kalamazoo River crested on Tuesday, April 8, 1947, with the water rising at the rate of one to two inches per hour. By this time, because of the heavy rainfall, many homes in the Sherwood Avenue and Hicks Avenue area had 12 to 14 inches of water in their basements. Sherwood Avenue, shown here, was under nearly a foot of water.

JOHN F. EESLEY MILL FIRE. Probably Plainwell's worst disaster was the John F. Eesley Mill fire in 1932. It not only completely destroyed the Eesley Mill, but damaged all of the surrounding buildings. Many smaller fires were started all over the village because of the high winds, which blew the burning embers around. The fires threatened to destroy the entire business district. Here Plainwell citizens watch in horror.

JOHNSON AND BEATTIE FEED MILL. The Johnson and Beattie Feed Mill, a building adjacent to the Eesley Mill, was also leveled by the fire. Plainwell's fire department as well as fire departments from Kalamazoo, Allegan, Otsego, and Wayland, fought the fire for two hours before bringing it under control. Four firemen had to be treated for injuries during the fire.

GASOLINE TANKER FIRE. As a gasoline tanker truck driver was passing through Plainwell on April 26, 1947, his tanker containing 4,000 gallons of gasoline caught fire and exploded, spraying gasoline onto many nearby homes. The Plainwell and Otsego fire departments were called to fight the fire. The driver was only slightly injured when he leaped from the burning cab, but his gasoline tank trailer and cab were a total loss.

HOME DESTROYED. Clancy Farr's home was reduced to ashes. Trees, lawns, and houses started burning at an alarming rate. Alta Beach, a spectator, stated that she thought that all of South Main Street would burn to the ground. The pavement swelled and cracked from the intense heat. A fire truck was damaged when it threw a rod from pumping an excessive amount of water on the fire.

FIRE DEPARTMENT. Firemen's Hall was Plainwell's first fire station located on the flat iron (Hicks Park). The firefighters are, from left to right, John Gilkey, Bill Stewart, William Talbot, William Thomas, Frank Smith, George Stiff, Joe Balden, Fred King, John Williams, Milo Chandler, Harry Bush, and John Tomlinson. In 1903, the fire station was moved to the west side of North Main Street. (Courtesy of Ransom Library.)

A 1920 FIRE TRUCK. This is Plainwell's first motorized fire vehicle, a 1.5-ton 1920 Maxwell truck. The truck was especially equipped for fire service at the cost of $3,000. After using the truck for a year, firemen felt that it was quite inadequate because it was incapable of transporting all of the necessary equipment and the firemen.

SOULE FOUNTAIN DESTRUCTION. In April 1953, a driver from the Hide Company in Grand Rapids, Michigan, came to pick up rendering from the Murray Packing Company, now Packerland. He had a seizure as he was going through the red light in the center of town and lost control of his truck, hitting several parked cars and pushing a parked police cruiser into the fountain.

PARKED CARS DAMAGED. Citizens of Plainwell inspect damage to the cars parked along Main Street that were hit by the Hide Company truck driver. One pedestrian was narrowly missed in the accident. The driver, hired the previous day, legally should not have been driving since he had a history of seizures.

EMBEDDED POLICE CAR. Pictured here is the Plainwell City Police car embedded in the Soule Fountain. As a result of this accident, the fountain had to be removed. The city was without a fountain for 17 years until enough money was raised by the junior chamber of commerce to rebuild the landmark.

SNOW STORM. Located in the snowbelt, Plainwell has had its share of snowstorms. On rare occasions, such as the January 1936 snowstorm, the area got more snow than it could handle. The heavy deep snow made many roads impassable. On Michigan Highway 89, east of the city, even the snowplow got stuck.

DOWNTOWN OTSEGO FIRE, 1900. Fire destroyed the Hall Block on February 26, 1900, as onlookers gathered during the late morning hours. Four stores and five apartments were burned in the fire that was blamed on a faulty first-floor stove. Paper mill pumps assisted the village's pumps, but the 30-year-old building was a total loss. (Courtesy of the Otsego District Library.)

THE 1902 SCHOOL FIRE. Schoolchildren examine the smoking ruins of the 1897 school building. It was actually Otsego's second major school fire, the first having occurred 39 years earlier. That 1863 fire destroyed a wooden-framed school that sat on the southeast corner of Farmer and Franklin Streets. (Courtesy of the Otsego District Library.)

RUINS, 1902. Otsego's high school building burned to the ground on January 30, 1902, just five years after being built. According to news accounts, the fire broke out at 9:40 a.m. and all 400 children and teachers were able to exit the building safely. However, the fire spread quickly and within a half hour the entire building was engulfed in flames. The loss was estimated at $15,000. (Courtesy of the Otsego Area Historical Society.)

THE 1908 FLOOD. Heavy snowfall in February 1908 and then rain and snowmelt in March 1908 wreaked havoc across southern Michigan as high waters flooded towns, destroyed buildings, and killed several people. The Kalamazoo River in Otsego rose dramatically, flooding basements of several riverfront factories. The chair company and the three Bardeen paper mills were shut down for two weeks. This image shows the river near the main Bardeen plant. (Courtesy of the Otsego District Library.)

FLOOD DAMAGE. This scene shows some of the damage caused by the 1908 flooding. The only visible evidence of Otsego's Island Park is the row of trees at left center. Even the footbridge leading from Farmer Street to the island was washed away. The flooded sheds of the Otsego Chair Company on the right would be in the vicinity of today's river walk path. (Courtesy of the Otsego District Library.)

St. Margaret's Catholic Church, 1906. The Catholic Church in Otsego was organized in 1887, and this structure was built in 1890. This blaze on Christmas Day 1906 was thought to have originated from a crib being used in a nativity. The fire caused significant damage, but the building was eventually repaired and renovated. (Courtesy of the Otsego District Library.)

The 1931 School Fire. Another Otsego school fire—nearly 29 years to the day since the 1902 fire—destroyed the high school again. A week later, classes were being held again in buildings throughout town such as the Congregational, Baptist, and Methodist churches, the public library, and at the American Legion Hall. By 1932 a new school was ready for students. (Courtesy of the Otsego District Library.)

OTSEGO SCHOOL FIRE, 1952. At 1:00 a.m. on February 15, 1952, a passing motorist spotted flames at the elementary school building on West Allegan Street. The Otsego Fire Department with the help of crews from Allegan and Plainwell had it under control within three hours, but the building was damaged beyond repair, resulting in the loss of 13 classrooms and the library. (Courtesy of the Otsego District Library.)

DESTROYED OAKWOOD BUILDING. This photograph shows the extent of the February 1952 fire at the Otsego School complex. Local residents were thankful the fire did not severely damage the adjoining and newer 1932 section. Students were displaced once again to various locations throughout the city to finish out the school year. (Courtesy of the Otsego District Library.)

FIRE HALL, C. 1915. Pictured here is perhaps Otsego's first fire engine, a horse-drawn model. The hose cart in the right stall is still owned by the fire department and is often featured in parades. A hose cart was pulled as fast as possible to the fire scene by a team of men. Muddy and sandy roads often made the going difficult for yesterday's firefighters. (Courtesy of the Otsego District Library.)

OTSEGO FIRE DEPARTMENT. The men of the Otsego Fire Department are shown in a pose before they headed door-to-door in an effort to collect money for the annual muscular dystrophy drive. From left to right are (first row) Jim Clark, Bernard "Speed" Holmes, Dick Wisnaski, Del Smith, Garold Bruner, Lewis "Pooie" Wilder (sitting in chair), George Tishhouse (kneeling), Harry Durkee, Howard Snyder, John Henry, Ed Seibert, Al Rogers, Bob Healey, and John DuBois; (second row) Clyde Kivell Jr., unidentified, Dick Watson, and unidentified.

111

FIRE DEPARTMENT VEHICLES, 1923. Frank Huddleston and Ira Stevens sit atop Otsego's motorized firefighting vehicle. On both sides are hose carts ready to go. On the wall to the left is the receiver and bell for all of the fire alarm call boxes located within the city. In 1923, Otsego had 15 alarm boxes mounted to poles or buildings at various street intersections. (Courtesy of the Otsego Fire Department.)

Seven
RECREATION AND LEISURE

ISLAND PARK, C. 1905. The strip of land in the river near the Farmer Street Bridge held a city park for nearly 50 years. While now overgrown with shrubs and reduced in size by damaging floods, the island once was a well-manicured and popular place to visit with friends and family. Residents could access the island by way of a footbridge connected to Farmer Street and attend Sunday concerts or stroll along its paths. (Courtesy of the Otsego District Library.)

OTSEGO FIRE DEPARTMENT, 1889. Posing for a group portrait before the Fourth of July parade in 1889 were Otsego's firemen and hose cart running teams. Hose cart races pitting Otsego against Plainwell were fun yet competitive events, and they frequently took place on parade days. This photograph was most likely taken on Platt Street or Court Street. (Courtesy of the Otsego District Library.)

OTSEGO HOSE CART RUNNING TEAM, C. 1900. The firemen from Otsego had a superb hose cart running team, but they usually came in second place. The events would draw the attention of the whole town, and big crowds turned out. Special excursion trains took local fans to neighboring towns like Three Rivers, Dowagiac, and Hastings, and the newspaper always provided the details surrounding each race. (Courtesy of the Otsego District Library.)

EDSELL'S OPERA HOUSE. In 1881, Wilson C. Edsell built the Edsell Block on the southeast corner of Allegan and Farmer Streets. Several businesses occupied space here over the years, including a bank, drugstore, restaurant, and a department store. The opera house was on the second floor, and it regularly hosted plays and musicals, high school graduations, vaudeville, and even traveling medicine shows. The curtain shown here was made locally and still exists today. The opera house was used in later years for meetings and occasional dance practices, but the entire building fell into disrepair, and it was demolished in 1968. The site is now used as a parking lot for a restaurant. (Courtesy of the Otsego District Library.)

Mr. *Irving Clapp*

THE
OTSEGO DANCING CLUB

Would be pleased with your company at their series of parties to be held at

EDSELL'S OPERA HALL,
OTSEGO, MICH.

PRESENT THIS AT THE DOOR.
NOT TRANSFERABLE.

MUSIC—SQIER'S FULL ORCHESTRA,
OF GRAND RAPIDS.

OFFICERS OF THE CLUB.

C. D. STUART, PRESIDENT.
R. MONTEITH, SECRETARY.
E. D. YECKLEY, TREASURER.

EXECUTIVE COMMITTEE.

HURON HALL. EBER SHERWOOD.
 F. F. WARD.

Floor Managers.
HENRY MONTEITH. F. F. WARD.

115

LADIES LIBRARY ASSOCIATION, C. 1895. Women's literary groups became popular in the late 19th century. Otsego's group started in the 1870s. They drew national attention in 1891 when they attempted to sell kisses for $1 to raise money and pay off the mortgage on their new South Farmer Street library. The kissing idea was unsuccessful, but attention to the cause helped them meet their goal. (Courtesy of the Otsego District Library.)

OTSEGO BASEBALL TEAM, 1902. Otsego gained notoriety in 1902 for recruiting two Negro League stars from the traveling Chicago Union Giants halfway through the season. David Wyatt and Andrew "Rube" Foster played in 12 games for Otsego. Wyatt later became a well-known sportswriter, and Foster achieved fame as a ballplayer and as the "Father of Negro League Baseball." Rube was inducted into the National Baseball Hall of Fame in 1981. (Courtesy of the Otsego District Library.)

OTSEGO CORNET BAND, C. 1885. Originally known as the Monteith Band because of the four Monteith brothers playing, it later came under the supervision of C. I. Clapp in 1881. He is seen in this image directly beneath the center tree and holding a trumpet. The band was photographed on the Mansfield Lawn, the current site of the Masonic lodge. Notice the Hall House (Winkel Funeral Home) in the background. (Courtesy of the Otsego Area Historical Society.)

OTSEGO CORNET BAND, 1912. Thomas Tate led the Cornet Band at this Fourth of July celebration in downtown Otsego. For years, Otsego had a community band that would play at holiday gatherings, parades, and Sunday concerts at the Island Park. Today's River Cities Concert Band consists of local Plainwell and Otsego residents who regularly provide concerts throughout the year. (Courtesy of the Otsego District Library.)

OTSEGO TOWNSHIP LIBRARY. Otsego's first library was built for $800 in 1891. The Ladies Library Association led the charge for the new facility. They sold it to the township in 1905 for $1,500. It served Otsego until 1971, when a new library was built one block south on Farmer Street. To the left of the library, notice the entrance to the roller-skating rink. (Courtesy of the Otsego District Library.)

DOLL PARADE, 1913. Otsego took great pride in its doll parades. Led by parent organizers, children decorated themselves, their dolls, and their buggies and then walked down the street during the annual fall homecoming parade. Boys participated by dressing as firemen, politicians, cowboys, and athletes. During the town's 1931 centennial celebration, the *Otsego Union* reported that 20,000 people attended the parade. (Courtesy of the Otsego District Library.)

McCall's Grocery, c. 1915. Parades offered business owners the chance to advertise their goods. Bert McCall first went into business as a grocer in Otsego in 1898. His store was located on the west side of North Farmer Street, where Otsego TV was located for many years. The site had previously been occupied by the Carter Blacksmith Shop and the Monteith Harness Shop. (Courtesy of the Otsego District Library.)

Scout House Dance, 1950s. The Eber Sherwood family donated the money for a building to house the Boy Scout activities of Otsego's Troop 99. Dedicated in 1938, it has since been the scene of many meetings, award ceremonies, and Friday night dances. Mary Alice and Leo Watters chaperoned the dances. Leo can be seen in the back right of this photograph. (Courtesy of Cora Lee Watters Greenburg.)

HOSE CART RACE. A hose cart race is about to begin between Otsego and Plainwell, rival firefighters. Competition between the two villages was a favorite sport. During a race in 1914, it was Plainwell's turn to go to Otsego. It was discovered, too late, that the Otsego hydrant coupling threaded in the opposite direction from those in Plainwell, consequently Plainwell lost the race.

FAIRGROUND. Here, in the late 1890s, a sulky horse race is in progress. Plainwell's fairground was located on Allegan Street (Michigan Highway 89) next to the present 131 Highway. After the fairground was abandoned, the city put its public ball diamonds on the property. The Comfort Inn and the Big Boy Restaurant now occupy this space. Throughout the years, horse races, track meets, fairs, carnivals, and circuses all set up on this spot.

CIRCUS CAROUSEL. The circus has come to town. Equipment for the circus is unloaded at the train depot on the east side of the village and transported across town to the set up area. In the early 1900s, children are lined up and waiting to ride the merry-go-round. It appears that this carousel was assembled downtown and not at the Plainwell Fairgrounds.

HIGH-WIRE ACT. A high-wire act is being performed on North Main Street in Plainwell after the circus came to town around 1900. The performer is walking on a tightrope from the tavern building on the east side of Main Street to the Village Hall on the west. Imagine the cost of liability insurance if this were to happen today.

PARADE. In pre-1920 Plainwell, any event was an excuse for a parade. There were parade celebrations for holidays, homecomings, wars, political events, harvest festivals, fairs, and even when the circus came to town. This particular parade is marching down West Bridge Street past the Ladies Library and Dr. Woolsey's home-office toward town. The Plainwell Military Brass Band is performing for the crowd.

PLAINWELL MILITARY BAND, 1913. Standing in the middle of East Bridge Street, the military band has paused to play a selection for onlookers. Note the early wooden buildings on the north side of the road. All of these buildings have been replaced. Some of the buildings on the south or right side of the street still remain. The Wagner and Heath clothing store is now Edward Jones, financial advisors.

EESLEY MILL COSTUMES. The year 1915 found students from the Bridge Street School gathered and waiting to line up for a parade. John F. Eesley, local mill owner, donated the Sunshine Flour Bags so that the children could make these wonderful bag costumes. At one time, the Eesley Sunshine Buckwheat Flour Mill was the second-largest producer of buckwheat flour in the United States. (Courtesy of Brad Keeler.)

SLEIGH RACE. Sleigh races were held in downtown Plainwell on Main and East Bridge Streets in the late 1800s and early 1900s. A local newspaper reported that a race was held on Saturday, February 16, 1907, with favorable weather and fine sleighing conditions. Three types of races were run, a green pacing race, a green trotting race, and a free-for-all for trotters and pacers.

THE 1918 PARADE. Pictured here is a World War I parade honoring those veterans serving in the war. A group of proud children carrying American flags are marching in front of the Lawrence House Hotel on East Bridge Street. In the background, a cigar store, which is part of the hotel, has several advertisements pasted in its windows, and the one above the door reads Rose-O-Cuba Cigars.

PRINCESS REDFEATHER. Shown here are Princess Redfeather and her troop on a float getting ready to participate in a 1930s parade. Princess Redfeather, an American Indian herbal doctor from the Cherokee nation in Oklahoma, ran a medicine camp three miles south of Plainwell on old U.S. 131. She came to the area and married local man Oscar Arthur "Pete" Peterson, a member of her traveling show.

HICKS PARK. Plainwell's oldest park, Hicks Park, was named in memory of Joseph Hicks, the village's first president. The park is situated in the center of town on the flat iron. It was dedicated at the town's first homecoming in 1907. This park has undergone many changes since its inception. The city of Plainwell has six parks consisting of 13 acres.

SOLDIERS MEMORIAL BANDSTAND. The bandstand was built in Hicks Park facing Allegan Street as a tribute to the soldiers who fought in World War I. It was purposed in September 1920, but it did not become a reality until 1921 when enough funds were raised to pay for the project. Many a fun time was enjoyed on Saturday night with band concerts and silver dollar drawings. Demolition occurred in 1959.

PLAINWELL COMMUNITY ORCHESTRA. The Plainwell Community Orchestra, led by Harry Kools, was organized in 1926 from a small group of musicians to a final membership of 40. Their caliber of music equaled or exceeded musical groups from much larger communities. Due to a lack of funds, they were forced to disband in January 1936. Here the orchestra is ready to perform for an audience in the Plainwell Presbyterian Church.

THE 131 DRIVE-IN. The Kortes family, along with Charles Sears, owned the 131 Drive-In Theatre. The theater had its grand opening on June 8, 1950. Location for the drive-in was south of town on the old U.S. 131 Highway (now Tenth Street). The theater enjoyed its heyday in the 1950s and the 1960s. The drive-in closed in the fall 1984. (Courtesy of Lucille Kortes.)

SUN THEATRE. On April 26, 1927, Harold Kortes opened the new Sun Theatre in Plainwell. At first only silent movies were shown with Harold's wife, Edna, an accomplished pianist, accompanying the movies. Early on, vaudeville was also performed before live audiences at the theater. Harold retired in the 1940s, leaving the operation of the business to his son and daughter-in-law Stacey and Lucille Kortes. (Courtesy of Lucille Kortes.)

NORTH MAIN STREET SCENE. Notice the Sun Theatre on the right of this photograph, around the 1930s. According to the marquee, a double feature is showing, namely the *Docks of New York* and *Frontier Fugitives*. Over the years, four generations of the Kortes family served the community. The theater closed its doors on June 12, 1994.

BOY SCOUT PAPER DRIVE, C. 1947. Paper drives were excellent fund-raisers for Troop 99. Boys and their parents would turn out to collect papers from throughout the city, using loaned vehicles from businesses such as Healey and Healey Lumber, Shears Dairy, and the city of Otsego. (Courtesy of Cora Lee Watters Greenburg.)